COMPOSITIONAL EXERCISES FOR THE PAINTER

LUCIA A. SALEMME

COMPOSITIONAL EXERCISES FOR THE PAINTER

WATSON-GUPTILL PUBLICATIONS/NEW YORK

PITMAN PUBLISHING/LONDON

To Vincent and Lawrence

First published 1973 in the United States and Canada by Watson-Guptill Publications,
a division of Billboard Publications, Inc.,
One Astor Plaza, New York, N.Y. 10036

Published simultaneously in Great Britain by Sir Isaac Pitman & Sons Ltd.,
39 Parker Street, Kingsway, London WC2B 5PB
U.K. ISBN 0-273-00414-X

Manufactured in Hong Kong

Library of Congress Cataloging in Publication Data

Salemme, Lucia A.
 Compositional exercises for the painter.
 1. Painting—Technique. 2. Composition (Art)
I. Title.
ND1475.S24 751.4'5 73-6888
ISBN 0-8230-0877-0
First Printing, 1973

Acknowledgments

I extend my deepest gratitude to David Scott of the National Gallery of Art, Washington, D.C., for his invaluable assistance with regard to many of the reproductions in this book, and to my dear friends Louisa and Alexander Calder, Helen Rosenthal, and Olivia Chapman for their unswerving interest. I especially wish to thank W-G Editorial Director Donald Holden, who first launched me into writing, Margit Malmstrom for her fine editing, and Elizabeth Rogers for her patience in typing my manuscript. My thanks also to Stewart Klonis, Director of the Art Students League of New York; the Solomon R. Guggenheim Museum, New York; the High Museum, Atlanta, Georgia; the Courtauld Institute Galleries, London; the Musée Marmottan, Paris; as well as to Nancy Lipscomb of Scala Fine Arts Publications, the Perls Galleries, the Saidenberg Gallery, and the William Zierler Gallery, all in New York; to Sidney Barkan for his photographic work; and to the collectors and artists who graciously allowed me to reproduce their paintings in this book.

My very special thanks go to the students of my Tuesday Studio Workshop and to the Group of Atlanta Artists to whom I first gave the projects in this book.

Contents

Foreword

This book by Lucia Salemme, who is a distinguished member of our faculty at the Art Students League, is more than timely; coming as it does when we are in the throes of a re-evaluation of all the fads that have swept through the art world during the last two decades. Once again, sound composition is acknowledged as the basis for serious painting—no matter what the painting style.

Lucia Salemme reminds the reader that although composition is intrinsically intuitive, there are many elements involved in making a good composition—that is, one that works—that can be learned. These basic compositional elements will provide the structure necessary to bring to life poetic and emotional expression; without them, the expression runs the great risk of being merely maudlin.

Compositional Exercises for the Painter explains the essential elements that go into putting together a good picture, analyzing such compositional "musts" as perspective, volume, spatial relationships, value distinctions, movement and tension, and using color in composition. Each compositional idea is illustrated by a painting by an acknowledged master, past or present. Many of the painters represented, like Giotto, Raphael, Rembrandt, and Cézanne, to name a few, were the rebels of their day. They were the great innovators, pulling away from the art "establishment" and incorporating new influences from an ever-expanding world. Each master painting is analyzed and each is accompanied by a project in which the reader can put into practice the ideas discussed in a composition of his own.

I have known Lucia Salemme during most of her professional career. And the most important point I can make about this book is that she brings to it her extraordinary abilities both as a creative painter and as an instructor: a discipline firmly rooted in the classic art curriculum, coupled with a fresh, spontaneous quality that shows itself in her painting, in her teaching, and in the outlook and perceptions offered in this book.

Stewart Klonis
Executive Director
Art Students League, New York

PART ONE
COMPOSITIONAL BASICS

1. Circle, Square, and Triangle Together in a Nonobjective Composition

By intermixing the primary colors—red, yellow, and blue—you can create every color in the rainbow. Similarly, by combining the basic geometric shapes of the circle, the square, and the triangle you can invent any shape in creation. The purpose of this project, therefore, is to see how inventive you can be simply by taking these pure shapes and arranging them in a nonobjective composition.

The term "nonobjective" means that you'll be using shapes that have no reference to real objects or images. This will leave you free to concentrate on inventing an interesting composition on the flat, two-dimensional surface of your canvas. In this way, you'll be involved exclusively with the beauty of the shapes you've invented. Furthermore, these shapes will give you many opportunities to break up the picture surface as many times as you like with no concern for pictorial subject matter.

Let's study Kandinsky's sparkling painting. Note how he's placed perfect circle shapes in a cluster in the upper right side of the canvas and a bold variation of a half-circle shape in the top center that tapers to a fine pinpoint at its base, balancing delicately on the perfect triangle at the bottom of the canvas. Rectangular and square shapes complete the other areas, with elegant oblong and half-crescent shapes in the upper left corner. Every spatial area in this painting is a link that relates to the shape next to it. The chain reaction created by these shapes is what ultimately establishes the unity of the composition.

For your painting, think of doing a nonobjective picture using the three basic geometric shapes: the circle, the square, and the triangle.

Materials:
Canvas, 18" x 24"
Full palette of colors
Assorted brushes

Begin by making several sketches using circular and rectangular shapes. Make some large and some small, and plan to use the entire space so that every inch of the area is considered. See how inventive you can be in designing the different shapes. Bear in mind that the open spaces between the shapes are also compositional forms and should be carefully planned. Be guided by Kandinsky: he's the originator of nonobjective painting and his mastery will be a constant source of inspiration to you.

Transfer your best sketch onto the canvas and plan where your extreme dark shapes are to be, as these will be spots that will hold the other compositional ideas together. Select the colors that will express the mood you wish to render, and apply the paint with fairly smooth brushstrokes so that the surface textures of the paint won't distract from the purity of the forms.

Your finished painting should be a fine example of the nonobjective approach to painting, completely lacking in tedium and monotony.

Vasily Kandinsky: Riss (Raft), 1926.
Oil on canvas, 39½" x 32¼".
Collection of Mr. and Mrs. David Lloyd Kreeger, Washington, D.C.

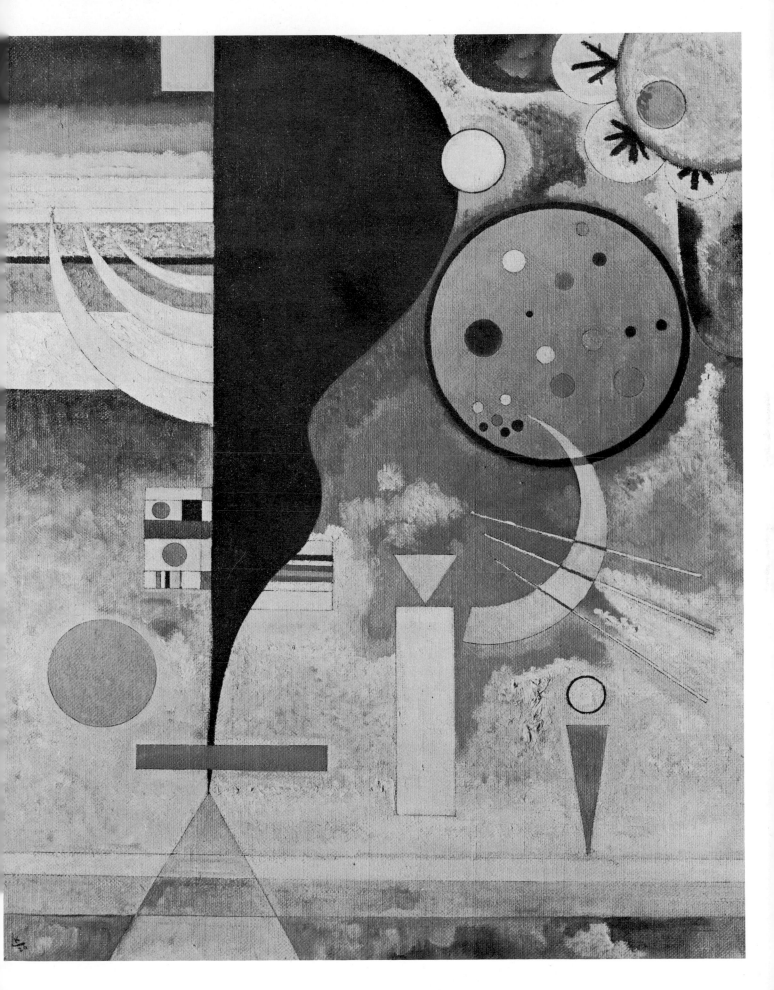

2. Nonobjective, Evenly Proportioned, Horizontal Composition

The purpose of this project is to use evenly proportioned shapes in a painting that shows little or no movement.

Study the painting here and use it as a guide. The first dominant feature that strikes the eye is the perfect juxtaposition of the dark forms that have been painted over a light ground color. The overall effect is almost like calligraphy, except that the forms have more substance and body than the letters in an alphabet. Since shapes that are in perfect balance do not suggest movement, the effect is one of restful serenity.

Materials:

Canvas, 18" x 24"
Cadmium yellow
Cadmium red
Cobalt blue
Titanium white
Ivory black
Assorted brushes

Turn your canvas to a horizontal position. Mix a fairly light value of any one of the three primary colors and use this mixture to coat the entire surface of your canvas.

On a separate sheet of paper, invent a series of nonobjective shapes that are all approximately the same size. (They needn't be *exactly* the same size, just so that they approximate each other proportionately.) See how varied you can make the shapes: long and narrow, short and squat, rounded edges, hard edges, straight edges, and some with both curved and straight edges.

Select the shapes that you find most interesting and transfer them to the previously painted canvas, separating them from each other by evenly proportioned spaces. Finally, paint the shapes in dark red, yellow, or blue. The resulting horizontal optical action will suggest an overall pattern, not unlike a page of hieroglyphics. Your finished painting should demonstrate that when shapes of the same size are placed in perfect balance, they automatically cancel all action and movement, thus creating an air of static calm.

Alfred Manessier: Variation of Games in the Snow.
Oil on canvas, 19¾" x 24⅛".
The Solomon R. Guggenheim Museum, New York

3. Landscape Using Nature Forms with Evenly Proportioned Vertical Spaces

As in Project 2, we're again involved in overall pattern-like effects, but this time you'll be using recognizable images that are all the same size, with the empty spaces in and around the subject creating the action —or lack of action. Also, this time your composition will be vertical.

For a start, look at the painting shown here. The artist has utilized static space to capture and hold the attention of his audience by surrounding the main subject with an astonishing variety of foliage, all more or less the same size, with evenly proportioned spaces that have a vertical direction. Although the optical experience here is vertical, Rousseau has avoided rigidity by using the curved contours of the leaves to counteract and soften the upright action of the tree trunks and vines.

Materials:

Canvas, 24" x 18"
Full palette of colors (see Project 1)
Assorted brushes

Choose a variety of leaves and flowers that appeal to you; you can gather them from a garden or get them from a florist, whichever is most convenient. On a separate sheet of paper, make preliminary studies of the leaves and flowers you wish to use in your composition. If you spread them on the floor or on a low table, you'll be able to see your subject from above; this makes a more interesting angle than flowers seen straight on, jutting out of a vase.

Simplify the structure of the flowers to stress the design more than the texture or the effects of light and shade. Note where the vines and branches begin and end, and arrange the flower forms around them. Now sketch the composition on a vertical sheet of paper, making sure all the *spaces* have similar proportions.

When your sketch is finished, transfer it to the clean canvas. The canvas should be in a vertical, upright position. You're now ready for your final compositional idea, the one that will act as a climactic area in the painting. Select a bird, butterfly, or animal; something in the world of nature that belongs with the type of leaves or flowers you've already sketched. For example, if the plants are tropical, a tropical bird of paradise flower would be appropriate. As for colors, choose any that you happen to like, just as long as they harmonize with the subject.

Remember: your main concern is to create a still mood. You want to surround the climactic area with quiet mystery. The evenly proportioned spaces between the leaves and flowers will help you achieve static space in this vertical composition.

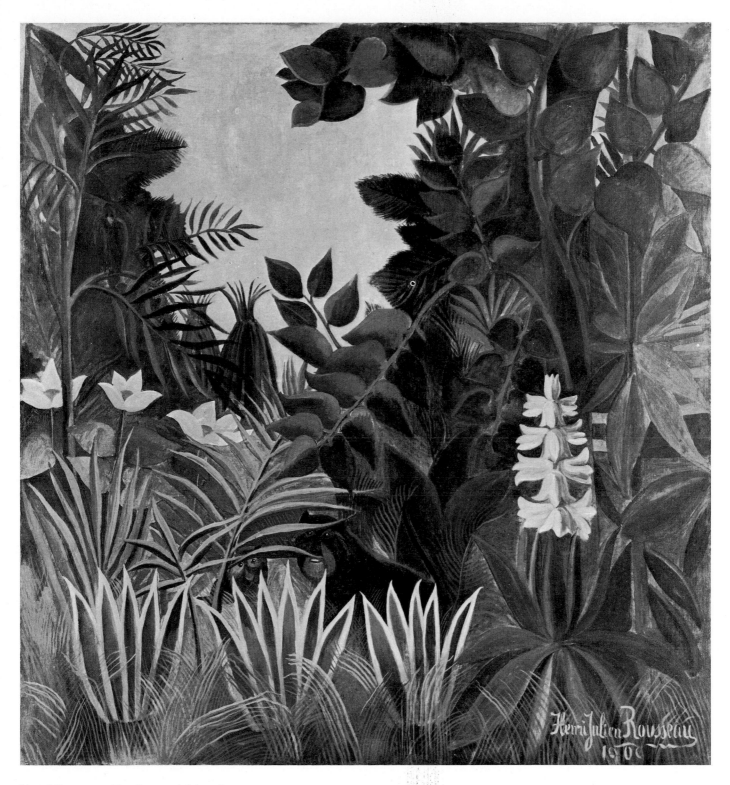

Henri Rousseau: The Equatorial Jungle.
Oil on canvas, 55¼" x 51".
National Gallery of Art, Chester Dale Collection, Washington, D.C.

4. Nonobjective Horizontal Composition Using Evenly Proportioned Spaces

This project will show you how to avoid the danger of monotony in a horizontal composition by using *uneven* or *rhythmic* spacing. Horizontals express repose and calm. To achieve this effect, you let all your shapes run completely across the picture, from edge to edge. But how can this device be varied enough to make it interesting? You can arrive at an extraordinarily quiet depth by making the shapes that lead up to the climactic area progressively larger or smaller, or varying their widths. Another suggestion is that your horizontal shapes needn't be perfectly parallel to the edges of the canvas. If you lift or tip up your shapes on the horizon, you'll produce greater vigor and tension. Or try lifting the shapes higher up where your center of interest is.

Jacques Villon has done just that in the painting reproduced here. Notice the uneven spacing that the artist has used to avoid tedium and monotony. He's planned the composition so that a horizontal rhythm dominates, giving the broad, flat areas a quiet depth and calm. But by lifting the center form so that it juts out above the main complex of forms, he's accented it and created a vigorous climactic area that further emphasizes the feeling of quiet repose.

Materials:

Canvas, 18" x 24"
Analogous colors (all of any one color: all reds or all blues, for example)
Assorted brushes

Place the canvas horizontally, and plan to use the space so that every area is carefully considered. Begin by sketching in the horizontal shapes, making sure that the open spaces between them are varied and rhythmic. You can achieve a greater feeling of repose by letting your *main* shape run completely across the picture, from edge to edge, so that it seems to expand or stretch itself in its horizontal action. You might widen this main shape in its center to single it out from the other shapes. Make sure the other horizontal shapes vary in width as they lead up or toward the main shape.

Plan your color relationships so they're in harmony. I suggest you use colors that are analogous—such as all blues, all reds, or all yellows—as any dissonance will disturb the feeling of repose you want to express.

Jacques Villon: Color Perspective.
Oil on canvas, 21⅜″ x 28⅝″.
The Solomon R. Guggenheim Museum, New York

5. Abstract Landscape Using Unevenly Proportioned Shapes

In this project we'll arrange shapes that are of different sizes on the canvas so that they convey a feeling of unexpected variety.

Remember that you're dealing with shapes: the manner in which you place them on the canvas is what will determine the end results. Have the shapes overlap or go behind one another. They needn't be isolated. Just keep in mind that the main shape should have the most prominent spot on the canvas: it will be the jumping-off point for expanding your background shapes.

Let's examine the painting shown here. A syncopated, light-hearted mood is expressed by distorting and simplifying natural forms and placing them in an irregularly spaced arrangement on the flat canvas. The off-center, irregular shape of the tree, painted in light tonalities, breaks up the space in a rhythmic, dynamic action. The areas surrounding this white shape play a subordinate role. The secondary motifs of vines and foliage support the main form. The artist makes no attempt to render two dimensions, and the shapes are all treated in flat applications of color, but their irregular contours nevertheless suggest forms in the round. Thus, the unevenly proportioned shapes, all painted in pure, high-key colors

and arranged in lively, irregular counter-rhythms on the flat canvas, create the feeling of unexpected variety.

Materials:

Canvas, 24" x 30"
Full palette of colors
Assorted brushes

First select a form in nature that you find interesting: a rock formation, for example. Place your main form in the most prominent spot on the canvas, making it the dominant motif. Take time in planning your composition and make several preliminary sketches of your main rock form.

Now plan the secondary compositional motif, one that repeats your main idea on a smaller scale, in a less prominent spot. Next, select the sketch you like best and paint it on your canvas, using a thinned wash of one of your neutral colors.

Last, decide what mood you wish to express and choose colors you think will express it best. Select high-key (light and bright) colors for gaiety and low-key (dark and restrained) colors for a somber, poetic mood. A combination of both will greatly accent the feeling of variety and unexpected surprise in a composition based on unevenly proportioned shapes.

Lucia Salemme: Summer Garden. *Oil on canvas, 21" x 31". Private Collection*

6. Upright Shapes in an Evenly Spaced Composition, Showing Perfect Balance and Stability

This project will show you how perfect balance can be suggested when forms and spaces are planned in an evenly arranged vertical composition. Standing objects, such as people, trees, city buildings and cliffs, have to be in perfect balance in order to remain upright. This is demonstrated in the painting shown here in which four abstract figures are placed in an evenly spaced composition. The sense of balance is accentuated by eliminating any reference to horizontals. The figures are placed in front of eight vertical planes that have been painted in alternating grays: very light—almost white—to medium-dark. The figures, on the other hand, are painted in bold, dramatic, contrasting hues; the interaction created between the background planes and the figures, along with the even placement of each in a compositional space, tends to check the movement of each, and a feeling of perfect balance is the final result. Although standing still, the figures seem poised for action and almost on the verge of going into a stately dance.

Materials:

Canvas, 16" x 40"
Cadmium red
Cadmium yellow
Cobalt blue
Titanium white
Ivory black
Assorted brushes

Instead of abstract figures, you may wish to use different vertical ideas: trees, city buildings, cliffs, or standing people. Suppose your choice is standing people. You'd start by making several preliminary studies of—for example—how people look while waiting for a bus. Simplify the figures: leave out the details and use flat applications of color with little or no modeling. Plan your composition so that the back spaces are divided into even, vertical compartments. Arrange your spatial planes so that the figures overlap the background spaces. This is where the interaction between the two areas takes place: the eye moves back and forth between the figure to the area behind it, setting in motion a balanced visual movement.

You're now ready to start painting, but first carefully choose your colors. For the background panels, select alternating light and darker value colors, saving the more dramatically accented values for the figures.

In order to strengthen the emotional content and give your composition a more majestic quality, use visible brushstrokes in a vertical action.

Your finished painting should express a perfect balance and stability.

Attilio Salemme: Engineer in the Kindergarten.
Oil on canvas, 17" x 34".
Private Collection

7. Illustrating a Literary Idea with Figures in an Unevenly Spaced Composition

One of the best ways to illustrate a story is to utilize elements of different sizes. The off-balance effect achieved by uneven forms and spaces within a composition not only creates movement but also makes for a feeling of unrest that serves to hold the attention of the viewer.

Let's put this to a test by painting a story picture, being guided by the Fra Angelico painting reproduced here. By utilizing two separate pictorial elements, the human figure on one hand and architectural structure on the other, compositional space is transformed into movement. All the elements in this painting are of different sizes: the figures are small and placed at opposite ends of the panel; the amazing variety of larger architectural forms act to connect the other compositional elements. The combination thus formed emphasizes the drama which is taking place.

From a purely structural point of view, notice how the arched doorway on the left surrounds the vertical figures, binding them together so they stay firmly put in the composition. By solidly framing the single figure in a doorway on the extreme right of the panel, the artist has artfully called attention to the drama being enacted in the picture. The uneven arrangement of the pictorial elements has created an interaction between the soft humanity of the figures and the solid structures that surround them. This uneven arrangement makes for the off-balance effect and is what creates the movement in the composition.

Materials:

Canvas, 18" x 24"
Full palette of colors
Assorted brushes

As a subject for your composition, another idea might be to plan a view of a courtyard, showing a building with three windows and a doorway, all of which are of different sizes. Invent a drama to take place in each room, as seen from outside—scenes of morning breakfast, for example. Have people enacting something of this idea in each window frame. Make a list of features that suggest a city backyard: fire escapes, awnings, shutters, window flower boxes, room interiors as seen through open windows. Use these details to create the story being enacted. Of course, you can have your figures enact whatever idea appeals to you; morning breakfast is just a suggestion.

Sketch in the architectural forms first, trying for a variety of sizes, then add whatever adornment you wish to the open windows and doorways, such as shutters, awnings, or railings. Fra Angelico used a very solid wall in the exact center of his panel to separate the room interiors from the patio. He used this device to unite his compositional elements and to reinforce his dramatic idea. See how diversely you can plan your building facade. The next step is to place the people so that their gestures will suggest early morning breakfast. In other words, although their actions will all be different—a woman cooking, a couple seated at a table drinking coffee, someone reading a newspaper—all will be engaged in a similar morning activity, breakfast.

Plan your color values so that the architectural areas are all fairly light in tone and painted with broad, flat brushstrokes. Use small, intimate brushstrokes of darker colors for the views of people in room interiors. In painting your story, you'll not only be aided by the uneven spaces but also by the interaction of dark and light values between the soft room interior views and the solid architecture of your building.

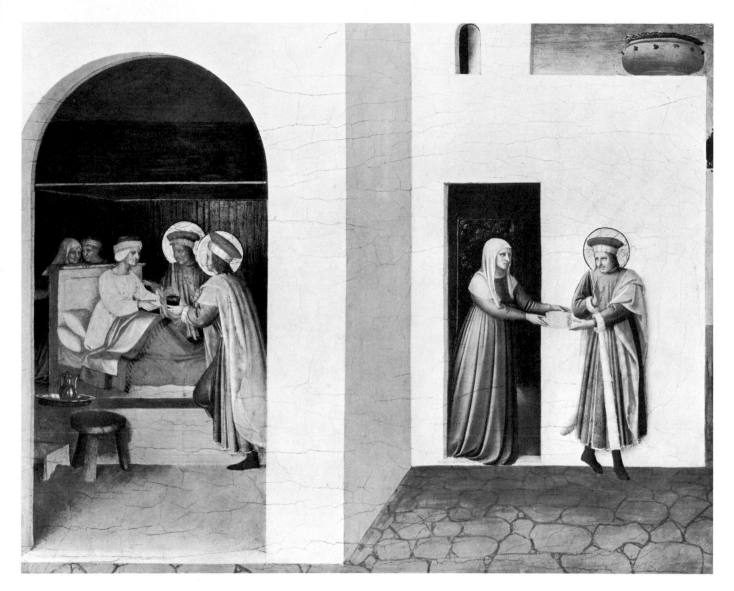

Fra Angelico: The Healing of Palladia by Saint Cosmos and Saint Damian.
Tempera on panel, 14⅜" x 18⅝".
National Gallery of Art, Samuel H. Kress Collection, Washington, D.C.

8. The Figure within a Triangle

The object of this project is to show how forms whose contours are opposite can create a unified harmony.

Let's look at Matisse's lively painting. The sensuous model is placed in the center of the canvas, and her torso, which forms a graceful arc, is complemented by a series of triangles ingeniously repeated throughout the canvas. Although the predominant triangle form is the obvious one made by the large armchair, the triangle idea is more subtly repeated in the action of the model's head and the patches of hair under each arm. The raised arms framing her head, and the legs bent at the knees, again repeat modified versions of the triangle. Together the triangles create a decorative overall pattern that sets off the fluid pose of the figure.

Materials:

Canvas, 24" x 20"
Full palette of colors
Assorted brushes

For a subject, you might think of a seated figure in a room interior. Using Matisse's painting as a guide, concentrate on the basic abstract shapes that the scene suggests. Place a large triangular form in the background area. This could be an artist's easel. A nude figure could be seated in front of it—perhaps a model resting between sittings. Emphasize the amorphic, or rounded, edges of the figure contours. Break up most of the background space with abstracted versions of the triangle motif. These could be enlarged shadow forms of the easel, or some drapery on the wall.

Now make a series of preliminary studies of your composition. Select the most successful sketch and transfer it to your clean canvas. See how inventive you can be in placing the hard-edge shapes behind the curved shape of the figure; you'll see that they complement each other beautifully.

The finished painting should illustrate how forms that are opposites can create unity and harmony if they're used to accentuate and complement each other.

Henri Matisse: Odalisque with Raised Arms.
Oil on canvas, 25⅝" x 19¾".
National Gallery of Art, Chester Dale Collection, Washington, D.C.

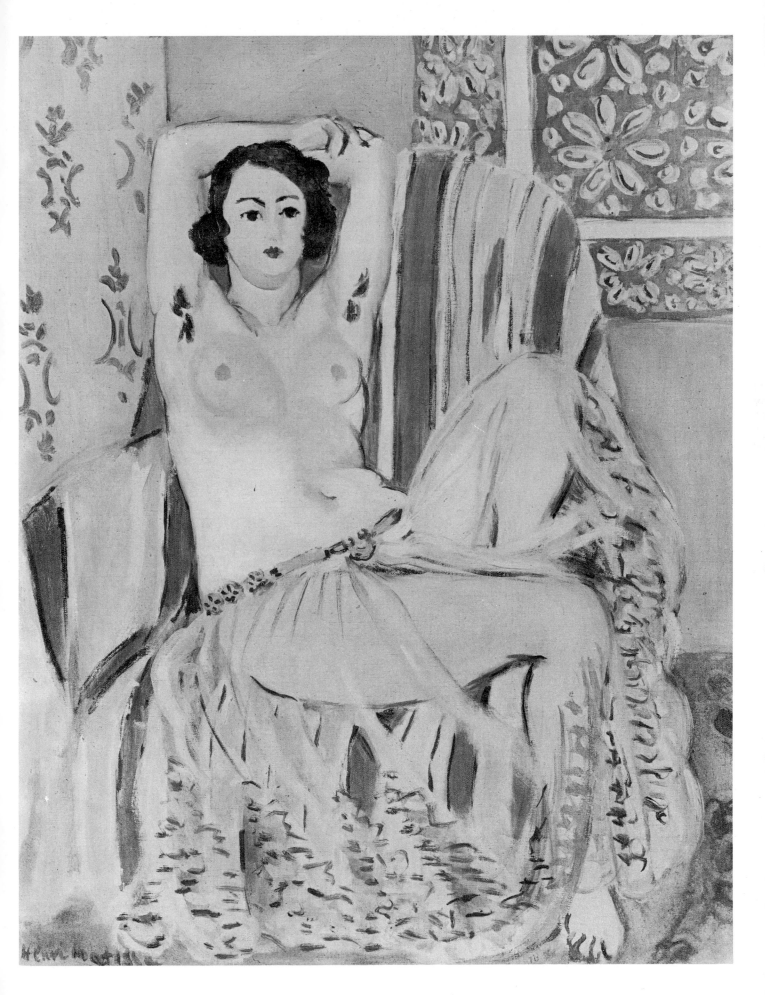

9. Symmetrical Balance, Using the Circle and the Square

In this project we'll be involved in the perfect symmetrical break-up of the compositional space, using a circle and a square. Symmetry is the most natural kind of composition: when there's a center shape with forms to the left and to the right and all around it in all directions, the picture areas are in perfect balance.

This idea is clearly expressed in the fine composition shown here. The main form is placed directly in the center, and is accented further by the circular shape placed directly behind it. The two sides are equally filled in with shapes that balance each other perfectly. The total result is a rendering of poetic mysticism in which realistic forms aren't needed to express the artist's subtle esthetic probings.

In doing a painting of your own, you may wish to use realistic images instead of nonobjective shapes. The most elementary interpretation of this idea would be to plan a composition of flowers in a vase placed in the very center of the canvas. In working out this project bear in mind that the result should be a painting showing perfect symmetry.

Materials:

Canvas, 18" x 24"
Full range of colors
Assorted brushes

It won't be necessary to work from an actual still life setup of a vase with flowers. Rather, plan your composition by sketching your own invented vase shape placed in the lower center half of the canvas. On the upper half, counterbalance the vase with the bouquet of flowers. For variation, you can balance different groupings of flowers in the arrangement. For example, one very large flower or leaf on one side balanced by two or three small ones on the other side.

The advantage of a symmetrical composition is that it's not difficult to achieve good results. Place your main subject in the center, fill the two sides with an equal number of forms or volumes, and you have a well-balanced composition—a basic structure upon which you can superimpose any poetic ideas you may have, worked out with a variety of textural effects and choice of colors.

Leo Manso: Samurai II.
Assemblage on Masonite, 50" x 40".
Rhode Island Museum, Providence, Rhode Island

10. Similar Proportions

In this exercise, we'll see how you can take a group of geometric shapes that are all of similar proportions and superimpose them onto squares of equal size.

Let's look at the painting shown here. Because the shapes are grouped together so ingeniously, optically they appear to be larger than they actually are, which causes them to change into new forms. The skillful manner in which the different tonal values are juxtaposed against one another and the inventive arrangements in which the artist has grouped the forms give each a distinctive identity. Although no attempt has been made to suggest depth, the forms seem to be floating in space while balancing one another; the result is an effect of cryptic mystery.

For our project we'll use a realistic idea instead of the nonobjective forms in Herbin's painting. Imagine an aerial view of a city. If you were a bird looking down, seeing a small portion of the scene, all the aspects would appear to be flattened out. What you would see would not be too unlike the nonobjective forms in the painting.

Materials:
Canvas, 24" x 20"
Full palette of colors
Assorted brushes

Make a preliminary sketch before painting onto the canvas. Break up the space into sections of equal sizes: these could be city blocks. Superimpose different-shaped buildings in each square; remember, you're seeing only the tops of the roofs so they can be any shape that strikes your fancy (circular, like the roof of the Guggenheim Museum, for example). Think of all varieties of structure that might be characteristic of city living and try to make them all more or less the same size.

Next arrange these views of tops of buildings into interesting group arrangements within your previously planned composition. You'll discover that your grouped-together shapes of similar sizes will change into brandnew forms, all having distinctive identities. Now carefully paint each rooftop with a variety of colors, being guided by what you think the actual colors really would be. I recommend you use smooth brushstrokes for the technique, as a rough texture might interfere with your design.

The overall effect of your completed picture, since you've made no attempt to suggest depth in this project, will be forms floating in pictorial space, and should result in a charming poetic balance.

Auguste Herbin: Composition on the Name "Rose."
Oil on canvas, 32" x 25⅝".
The Solomon R. Guggenheim Museum, New York

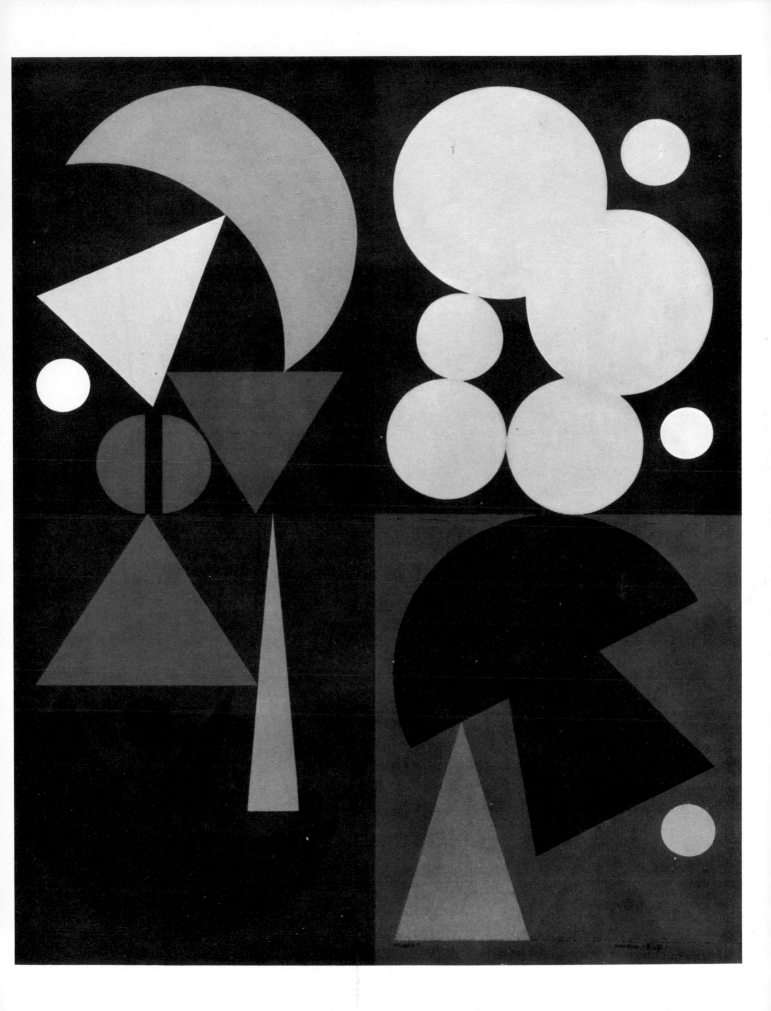

11. Dissimilar Proportions

Where the solid forms and open spaces of dissimilar proportions in a composition become the focus points, the resulting effect is one of vibrating liveliness. In this project, let's explore the dissimilar proportions in a country landscape.

Study the painting shown here and notice how the artist utilized this idea. The variety of dissimilarly proportioned structures in the composition, placed so they're in sharp contrast to one another, is what makes this painting so unique. The graceful sweep of the road as it circles the massive fort, the faintly visible cathedral in the far distance, the different sizes and shapes of the smaller buildings, and the reduced scale of the figures all agreeably complement each other.

By seeing the architectural elements in the painting in terms of their basic geometric counterparts, you'll notice that the road is really an oval, while the fort is basically a huge cone-shaped pyramid. The artist has utilized the graceful linear action formed by the circling road to emphasize the tremendous size of the fort. Where Guardi has used architectural structures to achieve his end, we'll use forms from nature for this project.

Materials:
Canvas, 24" x 18"
Full palette of colors
Assorted brushes

Think of forms and open-space areas in nature that are diverse in size: trees, fields, winding roads, people, farm animals, and all sorts of rock formations. Place your canvas in an upright position. Now paint two large trees standing close together, on either the extreme right or the extreme left side of the canvas. We're using two trees instead of one because two will provide an interesting space between them.

Since the trees will be the largest forms in your composition, they'll naturally be the focal point, and their off-center placement will make them the pivot around which all the other pictorial elements will revolve. Plan to have areas of open sky showing through the upper branches and foliage of the trees. The trunks should end at about the center lower half of the canvas, and the treetops should reach to the top edge of the canvas.

Now section off the canvas horizontally so that the upper half becomes a far-distance area. Sketch in rows of faintly discernible mountains or rolling hillsides in this background section. The two large trees will create the middle distance. Counterbalance their up-and-down action by having a semicircular road go around and behind them, similar to the winding road in Guardi's painting. Your road, however, can begin at the very bottom of your canvas. It thus becomes your foreground area. Have the road loop around the trees in a graceful, oval-shaped movement. The success of your composition depends on the contrast in size between all the elements in your picture. You can include small forms on your road: farm animals, or people involved in some kind of work. These small figures will create a marked contrast to the proportions of the trees and the road.

With its forms and spaces of dissimilar proportions, your composition should be vibrating with life.

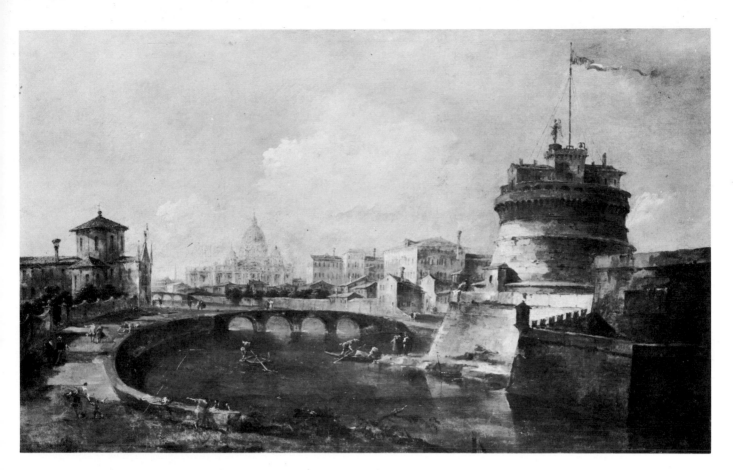

Francesco Guardi: Castel Sant' Angelo.
Oil on canvas, 18⅜″ x 31″.
National Gallery of Art, Washington, D.C.

12. Horizontal and Vertical Shapes Together in an Evenly Spaced Composition

When vertical and horizontal shapes are the same size as the open background space, they stop each other's movement on the canvas, and a feeling of order and balance is established.

In the painting shown here, although the images are varied, the spatial break-up is even so that the verticals and horizontals all have the same proportions. Léger has made no attempt to show visual depth, and the result is not unlike a tableau. The figures of the acrobats, trapeze artists, clowns, horses, musical instruments, and machine forms complete this unusual calm rendition of circus life. Because they temporarily stop each other's movements, the characters in the parade, who are all sharing an equal amount of both vertical and horizontal space, establish an overall sense of order and visual balance throughout the composition.

Materials:
Canvas, 20" x 24"
Cadmium red
Cadmium yellow
Cobalt blue
Ivory black
Titanium white
Assorted brushes

For a subject, you might try using city buildings to obtain the same effect that Léger does with people.

First sketch in a group of city buildings so that tall vertical skyscrapers break up the background spaces. In front or beneath the buildings, sketch in several horizontal, much shorter buildings. Have the rooftops stretch from left to right to form a series of horizontal cuts across the canvas. There's no need to render visual depth at this stage; the placement of the buildings will suggest depth after you've painted in the different surfaces of the structures.

Use many varieties of light and dark values of your colors: use the lighter-value colors for the light sides and the darker-value colors for the shadow sides of the buildings.

A very pleasant, calm view of a city scene should result from this placing together of vertical and horizontal shapes in an evenly spaced composition.

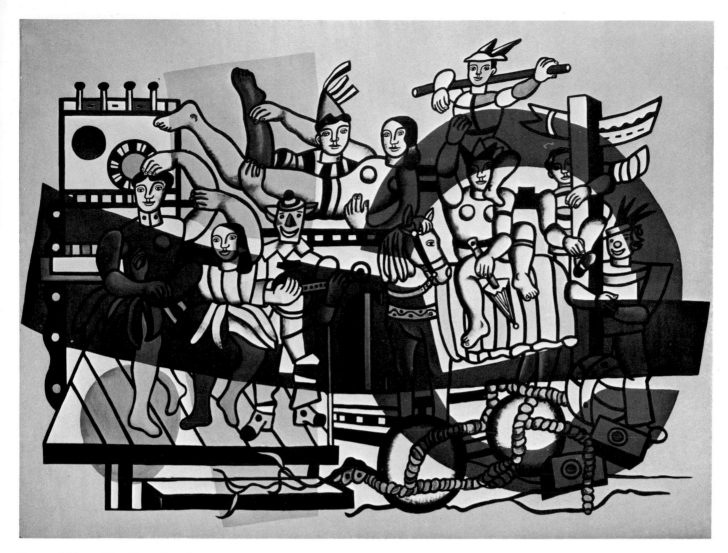

Fernand Léger: The Great Parade.
Oil on canvas, 117¾" x 139½".
The Solomon R. Guggenheim Museum, New York

13. Horizontal and Vertical Shapes Together in an Unevenly Spaced Composition

When both the shapes and the spaces between the shapes are uneven, the result is dramatic turbulence. In this project we'll use an uneven number of figures engaged in a group activity to illustrate this idea.

In the El Greco painting shown here, horizontal and vertical forms are placed in uneven spaces to create a feeling of dynamic turbulence. Elongated figures of different proportions overlap into the horizontal areas of interest and a tense feeling of foreboding is developed by the sharp delineation of the edges of each vertical figure. Consequently, the contours come alive with uneven movement. Notice how the horizontal landscape on the horizon is minutely detailed, while the reflected light from the sky accentuates the turbulence and sense of foreboding of the threatening sky and tormented figures.

Materials:

Canvas, 24" x 30"
Full palette of colors
Assorted brushes

Select a theme that expresses anxiety—for example, people running from a picnic ground during a summer storm. Have an uneven number of figures in the group, as this will add to the feeling of unrest.

First, plan your composition so that the figures dominate the space. Also, have the figures gesturing vertically. This will suggest a state of excitement. Remember, the gestures of your figures will tell us what's happening: show them in the act of covering themselves with spread-out garments or huddling under a tree for shelter. The pictorial elements are up to you, just so that you express a feeling of turbulence.

Next, plan the horizontal areas. You can do this with any horizontally formed paraphernalia that suggests a picnic atmosphere, such as a spread-out tablecloth on the grass or a horizontal fallen tree log.

Now plan the distribution of all the dark areas. You can paint your figures in very dark colors so that they're silhouetted against a light sky. El Greco painted all of his people in very light values against a dark background. You can do the opposite in your painting; the final result will be the same. Be very selective in the distribution of light and dark values, as this juxtaposition will accentuate the vertical and horizontal substructure already established in your composition.

Finally, proceed to paint in all the intermediate colors, always being careful not to disturb the balances of the dark and light areas you've already established.

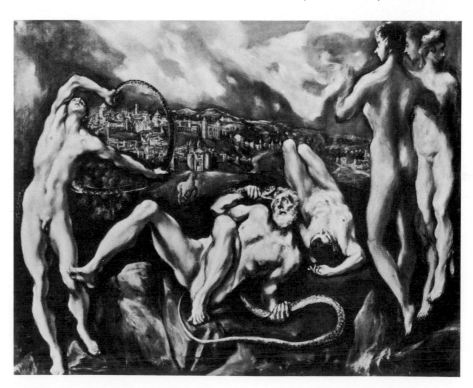

El Greco: Laocoön.
Oil on canvas, 54⅛" x 67⅞".
National Gallery of Art,
Samuel H. Kress Collection,
Washington, D.C

PART TWO
PERSPECTIVE

14. Showing Deep Space with Advancing and Receding Forms in a Landscape

When dealing with perspective, you'll find you can create an obvious illusion of deep space by planning your compositional areas in the following manner: the objects that you wish to appear closest to the viewer should be large, and placed near the bottom edge of the canvas; those that you wish to appear farthest away should be smaller, and placed close to the top edge of your canvas.

Let's put this to the test and do a painting showing deep space with receding and advancing forms in a landscape. The painting reproduced here is a perfect example of how all the unique aspects within a landscape can be used to express space. To surround his Holy Family in an atmosphere of profound serenity, Giorgione has silhouetted them against an idyllic landscape composed of receding and advancing forms that suggest deep space. Notice how strongly the figures are delineated and how they are proportionately larger than the other pictorial elements.

Materials:
Canvas, 24" x 30"
Full palette of colors
Assorted brushes

Make some preliminary sketches of trees, figures, and rock formations for subject material. In order to show deep space, it's best to divide your canvas area into four horizontal sections of uneven widths. Place your pictorial ideas in any arrangement that pleases you, just so you sketch the forms in the foreground, your figures for example, larger and close to the bottom edge of the canvas.

The next section up from the bottom of the canvas becomes a middle distance. Your rock formations could go here.

The third section up from the bottom of the canvas is the beginning of the receding distance. Here, objects such as trees, hills, or houses should be much smaller in scale than any of the other forms. You can further stress the illusion of distance by outlining the forms with sharp and definite edges: each of your forms should become stronger and more dramatic by degrees as you approach the bottom sections of the canvas.

The fourth section, or the upper part of your canvas, is the far distance. This part will naturally be the sky. Use soft, gentle colors here, much hazier at the edges. The sky determines the quality of light and the value scale of the colors for the entire picture.

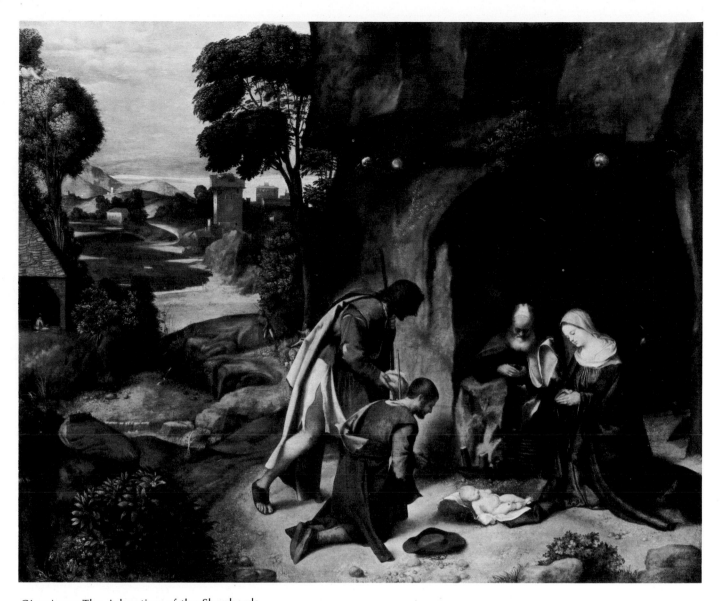

Giorgione: The Adoration of the Shepherds.
Oil on wood, 35¾" x 43½".
National Gallery of Art, Samuel H. Kress Collection, Washington, D.C.

15. Normal Vanishing Point

When we speak of a "normal" vanishing point we're generally speaking of one-point linear perspective, with the horizon line placed slightly above the center of the composition. The purpose of this project is to do a painting that shows this type of linear perspective.

We all know that linear perspective is an optical illusion. Perspective as we know it was discovered by the painters of the Italian Renaissance. Let's examine a typical example of Renaissance perspective, in which objects seem to diminish in size to finally disappear into the distance. Every aspect of the example of one-point perspective shown here, with its feeling of infinite depth, is intended to dramatize the message the angel has for the Virgin Mary. Placed at the lower right-hand corner of the canvas, the Virgin creates a mood of gentle introspection. Her form both supports and counterbalances the architectural elements in the background. The angel, kneeling on the path that leads directly through the arched doorway and toward the vanishing point, accentuates the sense of depth. The profound moment is further emphasized by the interplay of stark contrasts in the arches and pillars that surround the silent figures.

Artists have devised many ways to render the illusion of perspective on the flat surface of a canvas. The basic method is to draw a horizontal line, or horizon, across the canvas. This horizon line is the imaginary line in space that is parallel to the viewer's eye. Next, an imaginary dot is placed anywhere on the horizon line. This is the vanishing point. It is the point in space where all lines converge and seem to finally disappear.

But let's put all this to the test and work on a composition showing one-point perspective. I suggest you do a street scene showing an unbroken view of an avenue with buildings of different heights lining both sides of the street. Before planning the composition, make a list of whatever features you consider characteristic of a city street scene; lamp-posts, shop windows, people.

Materials:
Canvas, 24" x 30"
Full palette of colors
Assorted brushes

First, sketch your horizon line, placing it a trifle higher than the center of your canvas. Next, place a clearly defined dot, or pinpoint, somewhere on this horizon line (a little *off*-center always makes for more interest).

To indicate the street, start at the bottom edge of your canvas and sketch two diagonal lines, about 6" apart, converging and ending at the vanishing point. For more accuracy, you should use a ruler. These two lines form the street.

About 1" away, and on either side of the lines you've just sketched, draw two more lines. These also converge toward the vanishing point. These lines indicate the sidewalk. Next show the building line by drawing lines farther away from the two you've just drawn. You should now have a series of six lines all starting at the bottom edge of the canvas and stopping at the vanishing point. These will all be below the vanishing point and the result should resemble a wide open fan.

Now for the buildings. To get the perspective of any shape, draw only one side of each shape at a time. So think of the buildings as cubes, and sketch only one side of each. This will be the side directly facing the viewer; it is *not* in perspective.

Taking one building at a time, draw guide lines that begin at each of its four corners and end at the vanishing point. Next, cut off these guide lines to trim the building down to whatever size you wish it to be. Erase the guide lines at the point where the building ends. Your buildings should look like a succession of cubes and rectangles of various shapes, getting smaller in size as they approach the vanishing point.

Now you're ready for the details. Any ornamentation on windows and doorways must also be in perspective, so be sure to consider this. If you include figures, they, too, should be in perspective—larger in the foreground and smaller as they get closer to the vanishing point.

A certain amount of refining is always necessary in finishing a painting; when dealing with architectural subjects it's especially important. The slightest variation in the angle of a line can throw the whole compositional balance off.

The last step before you start to paint is to establish a definite source of light. The direction of the light will determine which sides of your buildings will be in light and which will be in shadow.

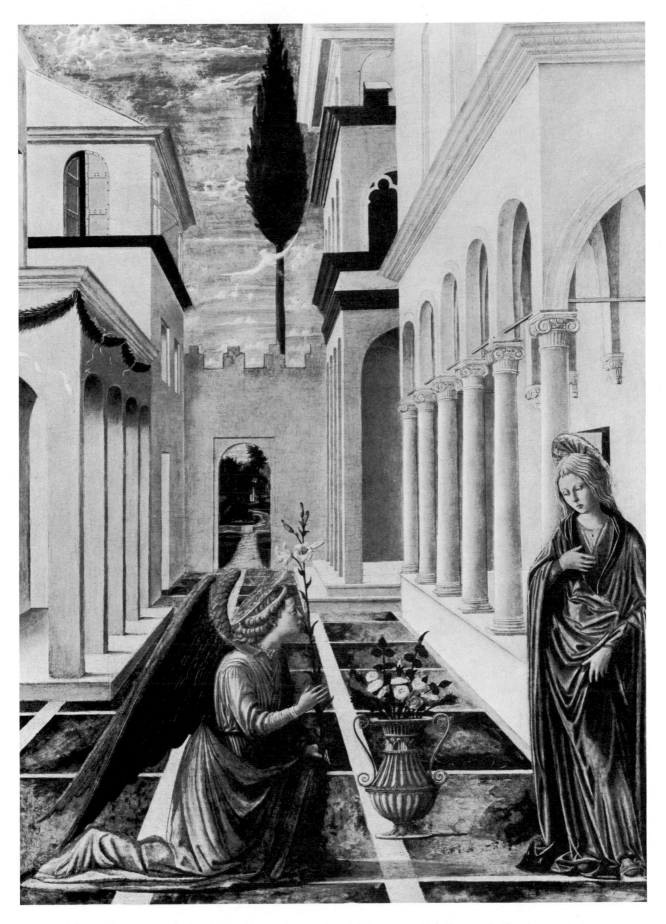

Master of the Barberini Panels (Umbrian–Florentine, active third quarter 15th Century): The Annunciation.
Tempera on wood, 34½" x 24¾". National Gallery of Art, Samuel H. Kress Collection, Washington, D.C.

16. Violent Vanishing Point

The use of the "violent" vanishing point is necessary when you wish to express a dynamic version of a pictorial idea.

The dynamic action in the painting shown here has been achieved by placing pictorial elements in the composition both above and below eye level. The effect has been achieved by using an elevated train structure and a stairway leading up to it, which form a zigzag movement that adds to the liveliness of the picture. Even though this painting has one vanishing point, because it's placed high up on the canvas and very off-center, the effect is one of violent action. The values used are also extremely contrasting, repeating the excitement already created by the violent vanishing point.

To put the concept of the violent vanishing point to the test, I suggest you use the three basic geometric shapes: the circle, the square, and the triangle. Render them as three-dimensional objects: the square will become a cube, the triangle a pyramid, and the circle a sphere or cone.

Materials:

Canvas, 20" x 24"
Ivory black
Titanium white
Assorted brushes

The first step in exploring the dynamic effect of the violent vanishing point is to establish your horizon line fairly high on the canvas (about one-quarter of the way down from the top edge will do). Draw this line across the canvas, then place a vanishing point on it (way off to the side is best).

The next step is to carefully draw a series of squares, triangles, and circles anywhere you please on the canvas, above or below the horizon line (make the forms close to the bottom edge of the canvas larger in size than the ones closer to the top edge). Now let's create the perspective of each form. Taking one shape at a time, carefully draw guide lines from each of their corners, ending at the vanishing point. When you've done this, cut the guide lines off at the far contour of the shape.

After getting the perspective of each of your forms you'll see that they've now all become cubes, pyramids, cones, or spheres. To better concentrate on the three-dimensional quality of your forms, I suggest you use a neutral color scheme. With black and white mixed together, try for a group of five different tonalities of grays, starting with very dark and getting lighter by degrees as you go toward white. A neutral color scheme will be a great help in heightening the three-dimensional quality of your forms.

Now paint in all your large areas: first the sky, making it a very dark gray, then the ground area in a very light, almost-white, gray. Visualize a light source so you can keep track of both the light side and the dark side of each of your forms. You'll find that the dramatic quality of the composition will be intensified when you have sharp light areas defining the different forms. Indicate a cast shadow on the dark side of each form. This will underscore the unusual perspective of each shape.

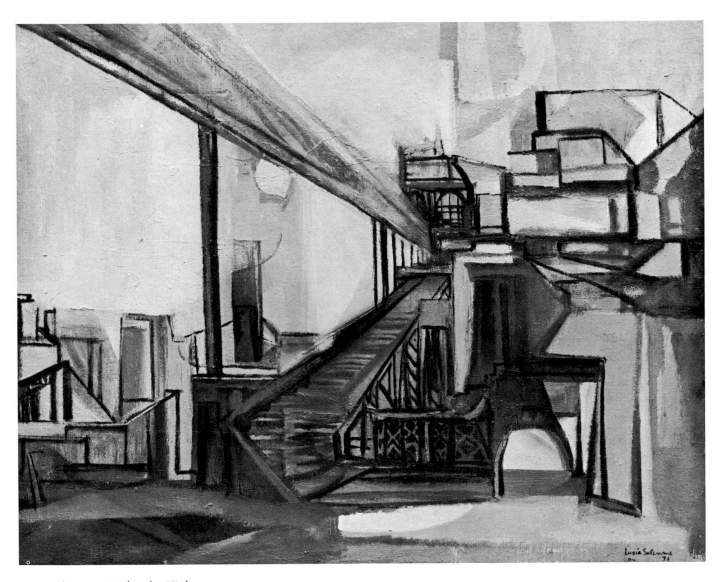

Lucia Salemme: Under the Highway.
Oil on canvas, 24" x 30".
Courtesy of the William Zierler Gallery, New York

17. Dramatic Foreshortening, with the Vanishing Point at Eye Level

Foreshortening is one of the basic principles of perspective and is most apparent whenever the human figure is part of the composition. In foreshortening, the first thing to observe is whether your view of the subject is above or below eye level, or, like in Mantegna's famous painting shown here, at eye level, where the horizon line and vanishing point are directly parallel to your vision.

When seeing the subject from this angle, the forms closest to you appear much larger than those farther away, creating an illusion of startling distortion. This illusion is aptly demonstrated in Mantegna's painting: the chest and ribcage of the dead Christ seem enormous when compared to the thighs and legs.

Here are a few hints to help you paint a direct-eye-level picture of your own. Imagine lying on your stomach on a beach and looking at the figure of a companion sunning himself, lying with the back of his head facing you. You'd probably see a very large cranium, with shoulders and chest next in size, and the receding hands, legs, and feet getting progressively smaller the farther back they go.

For your painting, choose any subject that will help you explore the idea of foreshortening—a figure sunning himself on a beach is just a suggestion. But do a painting of a figure that shows foreshortening of arms, legs, hands, or feet.

Materials:

Canvas, 24" x 30"
Full palette of colors
Assorted brushes

First divide the space with your horizon line to get a direct-eye-level angle. This will be rather high on the upper edge of the canvas. (In Mantegna's painting it's off the canvas entirely.) Place your vanishing point in the direct center of the horizon line. Think of your figure as a rectangular form: first sketch in the box-like shape, then block in the human forms within this structure. Of course a certain amount of knowledge of human anatomy is essential before embarking on this project, and I suggest you work from a model if at all possible.

After you've made an accurate contour drawing of the figure, plan the shadow areas, taking into consideration the direction of the light. Next mix a good flesh tone and paint in all the middle values, then apply all the very light tones. Finally, paint in your details, using a small brush. As you can see, a great deal of patience is required—but the result will be well worth your efforts!

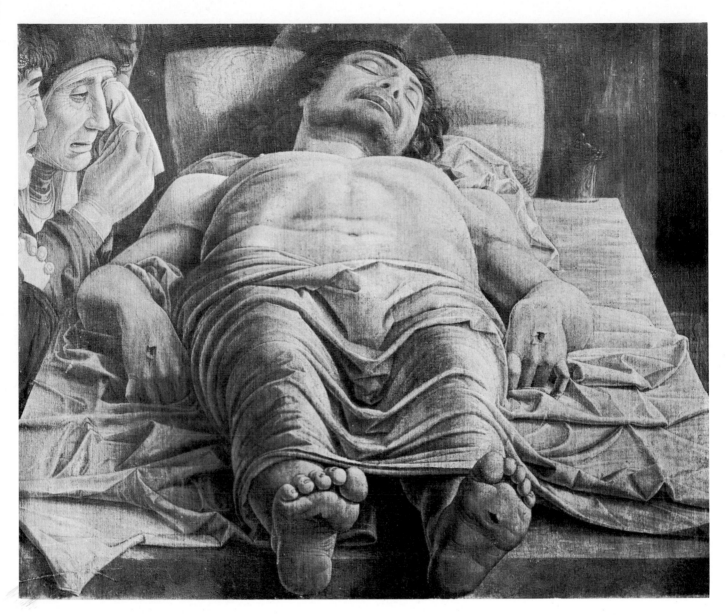

Andrea Mantegna: Dead Christ.
Oil on canvas, 32" x 27".
Galleria Brera, Milan.
Courtesy of Scala Fine Arts Publishers, Inc., New York

18. Linear Perspective Seen Below Eye Level

In this project we'll concentrate on achieving a below-eye-level view of a street scene. The term "below eye level" means that anything placed below the horizon line will appear *beneath* the viewer's vision: he'll see the *tops* of whatever objects he's rendering.

For your painting, think of a view that will show rooftops, chimneys, watertanks, and windows with awnings as seen from above. Remember that perspective is an optical illusion: things do not really disappear into the distance, or get smaller in size the farther away in space they go; artists have merely attained a skill in rendering this illusion on the flat, two-dimensional surface of the canvas.

But let's study Canaletto's marvelous painting for inspiration. Notice how he has foreshortened the figures—the tops of their heads and shoulders are slightly larger than the rest of their bodies—and notice how the tops of the umbrellas and tables catch the light. This light source plays an important role. It's focused directly onto the tops of all the forms, making them more attention-getting, and it casts long shadows onto the square, accenting the angle from which they are being viewed.

I've suggested a below-eye-level view for your painting because a scene is always more interesting when seen from a higher level. So let's begin a rendition of a street scene as seen from above.

Materials:
Canvas board, 18" x 24"

Full palette of colors
Assorted brushes

You can show distance by having the outside walls of buildings show perspective. This is accomplished simply by changing the direction of the horizontal lines and by diminishing the sizes of objects as they approach the vanishing point. Of course a knowledge of the mechanics of perspective is always helpful. Here are a few pointers.

To begin, sketch a line three-quarters of the way down from the top edge clear across the canvas board. This is called the horizon line. It's the imaginary line in space on a parallel level to the viewer's eye. Place a dot on the extreme right side of this line. This dot is the vanishing point, or the point in space where lines converge. The sizes of objects get smaller the closer they approach this point, until they seem to vanish completely.

Draw a series of lines that point directly onto the vanishing point. These will be your guides in sketching in the different horizontal features of your composition. Remember, the closer to the vanishing point your shapes get, the closer together they'll appear to be (like railroad tracks receding into the distance, with the ties getting closer and closer to each other the farther away the tracks get). You'll have a less complicated composition if you confine yourself to showing only one or two rooftops, with a chimney or a watertank and perhaps several figures on the sidewalk below.

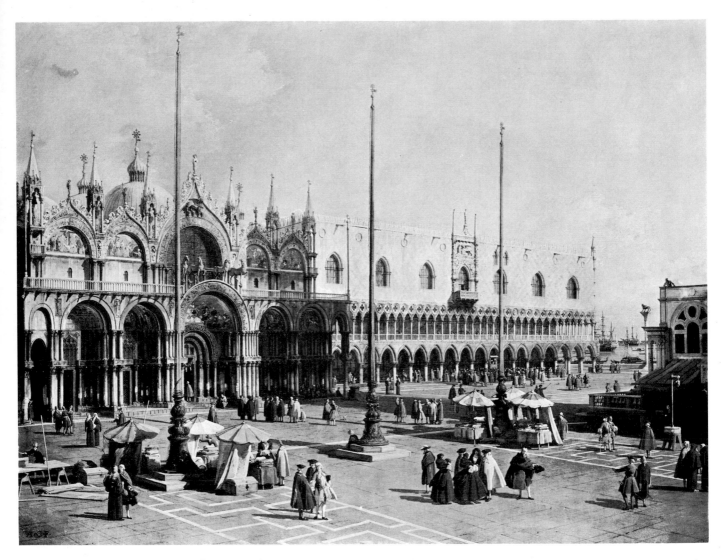

Antonio Canaletto: The Square of Saint Mark's.
Oil on canvas, 45" x 60½".
National Gallery of Art, Washington, D.C.

19. Space Seen Through an Opening

The purpose of this project is to demonstrate how when a landscape is seen through an open window or doorway with the room interior in the foreground, the view seen outside is as compelling as the room.

The de Chirico painting shown here is almost like a stage set in which an enigmatic drama is being played out. Placed in the middle of an unknown, solitary landscape, the two figures, deep in conversation, are oblivious to their strange situation. It's the feeling of solidity conveyed by the very solid figures of the man and woman surrounded by parts of the room that makes the perspective of the open spaces outside so far-reaching and inviting. In this type of composition, the spaces in the distance are as sharp as those in the foreground; they create an irresistible back-and-forth movement in the painting and every inch of the canvas is deeply felt.

Let's put this to the test and plan a still life. You might use a large vase of flowers, placed on a table in front of an open door overlooking a river view as your subject. This will provide you with ample pictorial elements with which to explore the idea of space seen through an opening.

Materials:

Canvas, 40" x 30"

Full palette of colors
Assorted brushes

Plan your composition so that the architecture of the room shows a large open area (half the size of the canvas) with a door swung open to the left side. Position the opening pretty much in the middle of the composition.

In the open space, carefully sketch in a seascape, showing sky, distant hills, and boats in the water. Paint all these in beautiful, airy, light blues.

Directly in the middle area of the canvas, paint a large bouquet of red and orange flowers, all large, such as tiger lilies, or chrysanthemums—or any others that you like, providing they're large and preferably red, orange, or light pink in color. This is so that the colors will contrast with the blue of the scene outside the doorway. Arrange the flowers in a large, dark-hued pitcher or vase.

Toward the bottom part of the canvas sketch a small end-table for the vase and flowers to rest on.

Finally, paint the walls and door frame in any color that has a medium-dark value. The whole idea is to provide a subdued color contrast to the airy scene outside the window.

Giorgio de Chirico: Conversation Among the Ruins.
Oil on canvas, 51⅜" x 38¼".
National Gallery of Art, Chester Dale Collection, Washington, D.C.

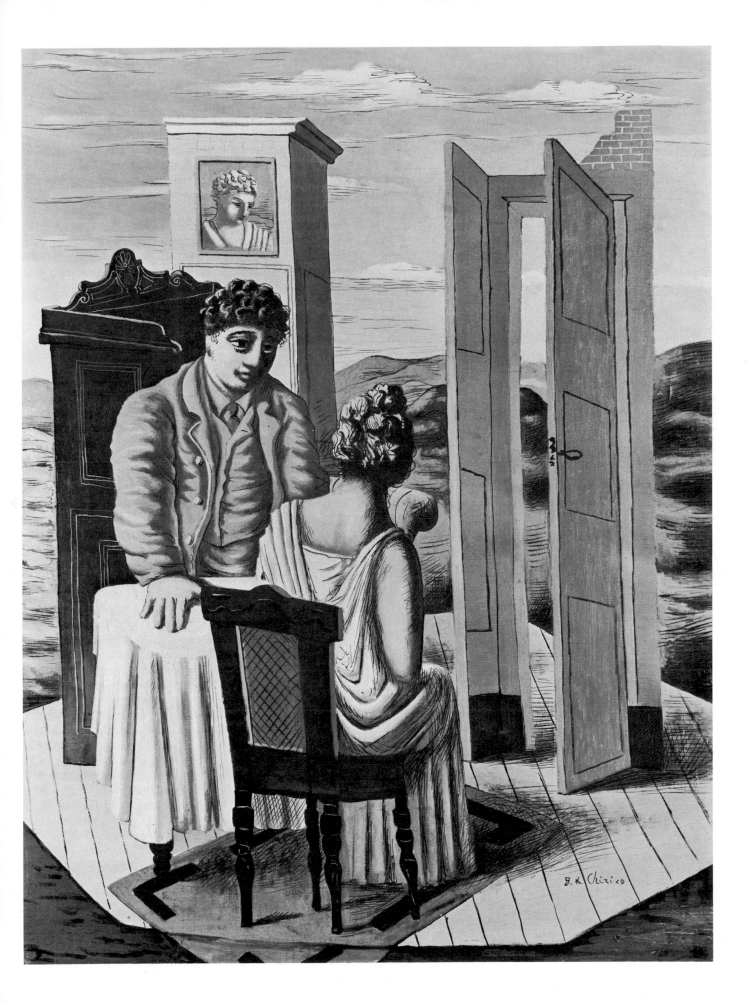

20. Space Through an Arch

The suggestion of deep space in a painting is often used to express emotion. This device may be used whenever the artist wishes to paint a poetic version of an idea. The purpose of this project will be to show deep space in a composition by surrounding a landscape with solid shapes. The solid shapes framing the scene will create the effect of a picture within a picture and another dimension will be achieved.

Study the arch and rock forms framing the distant landscapes in Bellini's beautiful painting shown here and see how he's done this. Saint Jerome is seated in the fore-ground, which is the largest area in the composition, and frames a series of landscape views seen from the open arch of an old villa. We somehow feel that the white walls of the city seen way off in the distance have some connection with the story in the book he's reading. By arranging a succession of five different images and systematically placing them one behind the other in diminishing sizes, Bellini has demonstrated how beautifully perspective can be used to emphasize and heighten an emotional idea.

Materials:

Canvas, 30" x 36"
Full palette of colors
Assorted brushes

For your subject, use the Bellini painting as a guide. Fantasize, if you like: the arch can either be part of an imaginary villa, the view seen through a garden gate, or Washington Square Arch. Choose the one you like best.

Next think of a figure seated on a bench, lost in thought while reading. Section off the canvas so that the figure is in the foreground, in front of the solid forms of the arch. Through the opening devise a succession of two scenes, one above (or behind) the other, then show the sky.

Now decide on the mood you wish to convey: sad, angry, happy, or peaceful. Select a group of colors that you think will express that mood. For example, if your mood is happy, use high-key colors such as yellows, pinks, oranges, and whites with some greens and blues for contrast.

Try to show a controlled difference between the values of the colors in the distance and those in the foreground. Again, study Bellini's painting. Notice how he's kept the entire foreground (including the figure) in light-value colors, the arch quite dark, and the landscape seen through the arch in medium values. You can do the same in your painting. Your finished painting will show that when man is represented in a natural setting the perspective acts as a symbol to heighten and emphasize his poetic ideas.

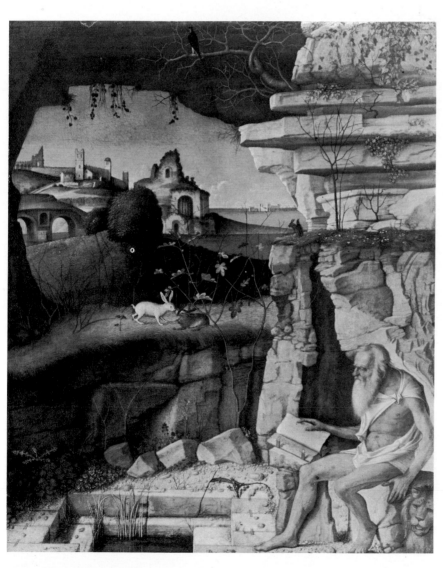

Giovanni Bellini: Saint Jerome Reading.
Tempera and oil on wood, 19¼ " x 15½ ".
National Gallery of Art, Samuel H. Kress Collection, Washington, D.C.

PART THREE
VOLUME AND DIMENSION

21. Sphere, Cube, and Pyramid as Volumes

In this project, we'll be studying the three-dimensional quality of forms and how to render this quality on the flat surface of your canvas.

In the painting shown here, the artist has taken a group of geometric shapes and set them up as still life objects arranged on a table. Whether the forms are real or not doesn't matter; what does matter is that they exist in a setting that evokes memories of all sorts of poetic ideas. The viewer becomes a partner to the artist in that he's allowed to participate in the interpretation of the forms. Each form has been beautifully modeled to convey its three-dimensional quality. The direct source of light coming from the left has a gentle, illuminating quality that bathes the still life in a hallowed glow.

Since our painting surface is flat, all suggestion of volume, or three-dimensionality, must be rendered through illusion. In this project, we'll paint an imaginary still life and build the composition around the three basic shapes: the sphere, as the basic shape for apples or oranges; the cube, as the basic shape for a table or room interior; and the pyramid, for wine bottles. By building around these three basic shapes, you'll be able to see the three-dimensional quality, the volume, of your objects. While we see them as flat, we can make them appear three-dimensional by accenting their lights and darks in sharp contrast.

Materials:
Canvas, 20" x 24"
Titanium white
Ivory black
Assorted brushes

First take another look at the painting: make a note of the fact that the artist has used but one source of light. Do the same in your picture. Since we're concerned mainly with rendering volume, I suggest you do a monotone painting using umber mixed with black and white to get gradations of grays.

As a first step, prepare your palette by mixing at least five different grays, ranging from very dark to very light. These, plus black and white, will give you seven tonalities to work with. Now sketch a series of spheres, cubes, and pyramids—such as apples, pears, a book, wine bottles—in an arrangement that suggests a still life on a table.

Next, decide where your source of light is. Paint in all the light sides of the objects, then the dark sides. Last, paint in all the middle values. These values should be painted in flat applications of paint, using a dry, clean brush.

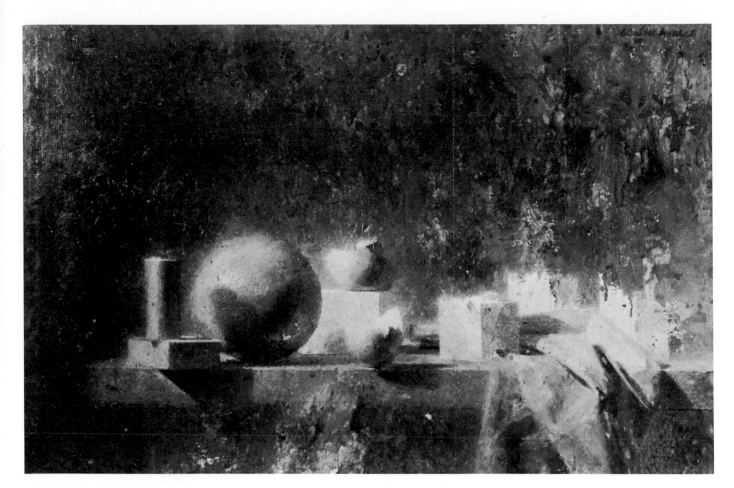

Walter Murch: Fragments.
Oil on canvas, 20½" x 30½".
Collection of Helen Mary Harding, New York

22. Sphere, Cube, and Pyramid Abstracted in a Landscape

In the last project we were concerned with seeing the sphere, the cube, and the triangle as solid shapes and modeling them in terms of their volumes. In this project, we'll concentrate on the juxtaposition of one form to another in an overall patterned landscape composition.

Study the painting shown here. The artist has modified the volumes of the nature forms in this abstract version of a landscape and transformed them into the basic geometric shape that each one resembles: the sphere, the cube, and the pyramid. He has eliminated the middle-tone value, and as a result, the stress is on the ingenious arrangement of the composition on the flat surface of the canvas rather than on volume or natural appearances. Notice how by removing all details and having but one source of light, the dark and the light sides of each form are in bright, sharp contrast, producing a sprightly abstract version of a landscape.

For subject material, be guided by this painting, and create an abstract landscape composition of your own.

Materials:

Canvas, 24" x 30"
Full palette of colors
Assorted brushes

Start by sketching a series of features that suggest a country landscape: trees, houses, bushes, rocks, rolling hills, people. Select the sketches you like best and transfer them to the canvas. As you work one form at a time, abstract your forms in terms of their basic geometric shapes: houses become cubes; tree trunks, cylinders; foliage, spheres; and people, cones.

Since your compositional plan was resolved in your original sketch, your only concern should now be to abstract each form. You can do this by eliminating superfluous details. Then decide where your light is coming from, depending on what time of the day you have in mind. For example, if it is to be noon, the sun would be directly overhead: only the tops of all your forms would be light, with the shadows directly underneath them. If it's early morning and the sun is from the east, the shadows would be elongated. Remember, in order to abstract a scene you must reduce the natural appearances to their essential basic characteristics; this applies also to the source of light. Therefore, it won't be necessary to be concerned with middle values, just the very light side and the very dark side of each form in the composition, plus whatever dark cast shadow you wish to put in.

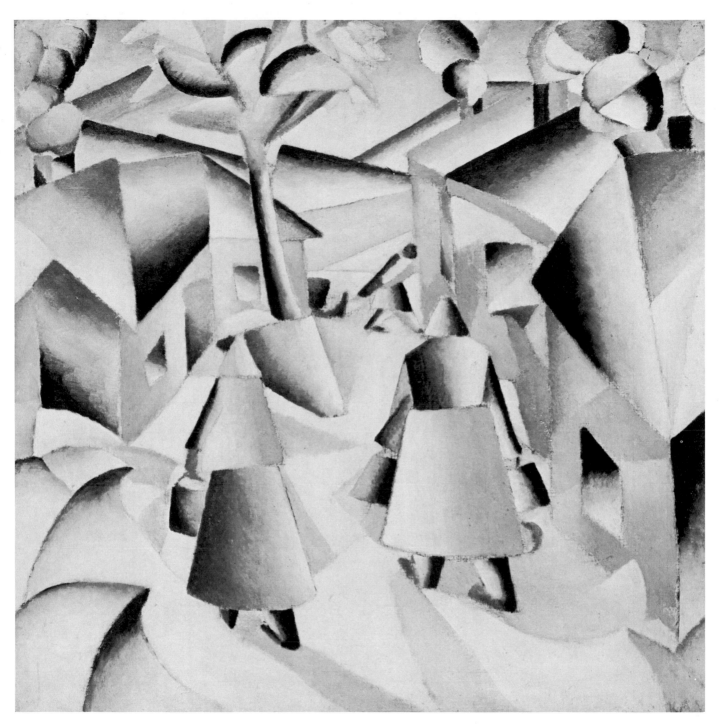

Kazimir Malevich: Morning in the Village After Snowfall.
Oil on canvas, 31½″ x 31⅜″.
The Solomon R. Guggenheim Museum, New York

23. The Circle Is Now a Sphere

In this project we'll be concerned with transforming the circle into a sphere. In other words, we'll look at the circle in terms of its volume.

Renoir's *Bather* is a delight to the eye; every detail adds to the marvelous mood of relaxed movement that the canvas projects. The artist has modeled the rounded forms and soft curves of the figure so that the solidity and volume of all the areas of the torso are distinctive.

Now try a painting of your own, using a figure from life as a subject.

Materials:
Canvas, 36" x 30"
Full palette of colors
Assorted brushes

Pose your model in such a way so that the contour lines form an interesting design. Place her so that the quality of light will give you ample opportunity to model the forms, as this is the only way you'll be able to render volume: the play of light and dark on the arms, breasts, and torso are the means by which you'll create the illusion of a curved surface on the flat plane of the canvas. Break up the picture surface so that the figure is the largest area on the canvas. You needn't do a full figure; like Renoir, you can show only one section, the torso with head and arms caught in an interesting gesture. Next plan a good abstract pattern of dark and light shapes. To get a definite light and dark side of the model's figure, direct the light onto one side only.

Now comes the big pattern of tonal values that will give the impression of volume. Model the rounded forms and soft curves, and blend the lights and darks together. Finally, paint in all the other pictorial areas, the background drapery, if any, and all the details. The modeling you've done in the rounded forms should shine through the final layers of paint, changing a flat circle into a voluminous sphere.

August Renoir: Bather Arranging Her Hair.
Oil on canvas, 36⅜" x 29⅛".
National Gallery of Art, Chester Dale Collection, Washington, D.C.

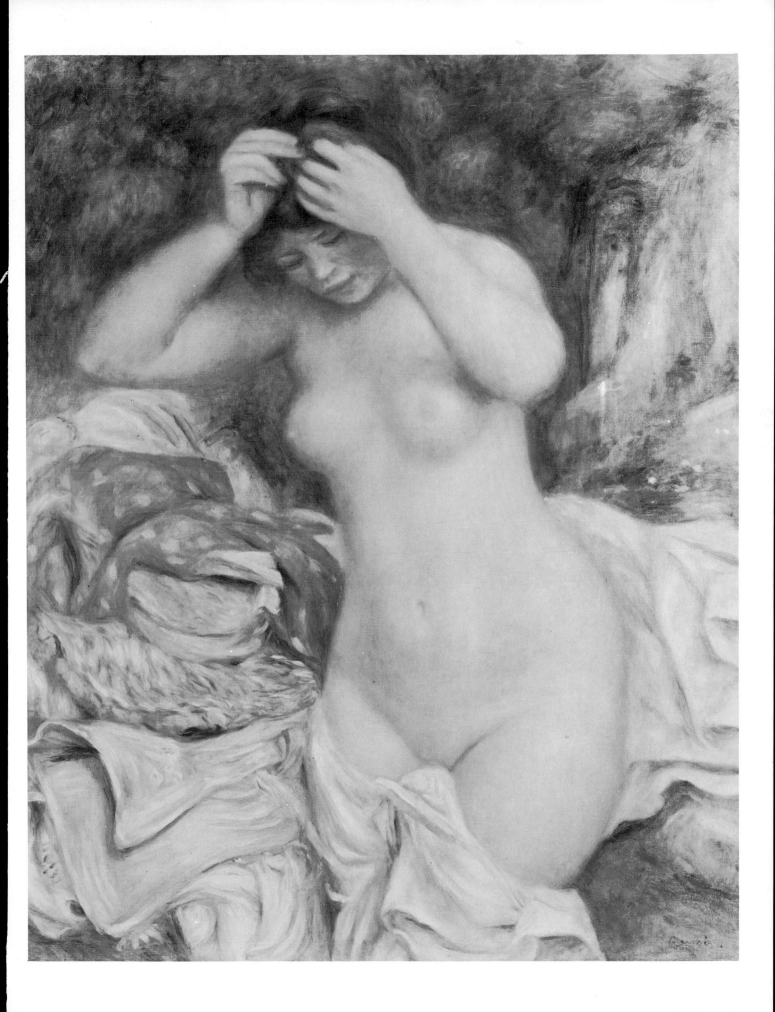

24. The Square Is Now a Cube

In this project, we'll change a square into a cube and then into a rock formation—to be different from Gris, who transposed his cube form into a series of rooftops! His series of angular forms, which come out looking like the tops and sides of buildings, are really nothing more than cube-like shapes with parts of surfaces visible.

Juan Gris: Rooftops. *Oil on canvas, 20⅝" x 13½".*
The Solomon R. Guggenheim Museum, New York

In this imaginative view of rooftops, all the planes in the picture are condensed into their simplest basic geometric forms, providing a poetic essence. The picture planes appear to be flattened against one another and the linear rhythms of all the edges of the buildings form an elegant design. Additional strong compositional contrasts are provided by the juxtaposition of dramatic dark and light areas.

The first step is to plan a good abstract arrangement of a series of cube-like shapes piled together, not unlike a child's set of building blocks. See how imaginative you can be in your painting: make some preliminary studies where you first sketch a series of cubes piled on top of one another, then modify them so that they resemble rock formations in nature. Place them in such a way as to suggest a rocky landscape. Don't try to depict a whole mountain range; rather, think in terms of one section that shows some unique aspects of rock formations peculiar to nature.

Materials:

Canvas, 24" x 30"
Full palette of colors
Assorted brushes

Sketch in the block-like shapes. In some, you'll be able to see only the top and one side; in others, only a side and the bottom. Make your blocks all different sizes. When you've come up with a satisfactory grouping, which should be rather topsy-turvy, round out and soften some of the edges on your cube shapes to resemble weathered rocks in a landscape.

Now that you've established the main theme, you can extend the composition to include a proper setting for the rock forms. Is it to be a park? The Grand Canyon? Some highly surreal place, like the moon? The main objective of this series of projects is to study volume and render its three-dimensional quality on the flat, one-dimensional surface of your canvas. Therefore, when starting to paint try not to lose the volume of the cube-rock forms already established in the composition. You'll have more control over rendering the different surfaces of each shape if you have one source of light directed on the rocks. Juxtapose the black and white areas, as this kind of strong contrast provides a lively pictorial image.

25. The Triangle Is Now a Pyramid

In this project we'll turn a triangle into a form that has volume. The shape that comes to mind for this is, of course, the pyramid. The number of sides a pyramid has depends on the contour of its base: if the base is triangular, the pyramid will have three sides; if the base is a square, the pyramid will have four sides. No matter how many sides a pyramid has, the sloping sides will meet at the apex, or top, and the silhouette will always be in the shape of a pyramid.

Let's look at Delaunay's imaginative rendition of the well-known Eiffel Tower, epitomizing the gaiety and lightheartedness that we all associate with Paris. By sublimating much of the iron grillwork of its structure and emphasizing the basic sweep of its upward action he's captured a buoyant, joyous mood. He's filled the compositional space with witty details in the sky, enhancing the light feeling of the painting. The surrounding rooftops act as a stacatto complement to the tower.

Delaunay has broken up the pyramid and turned it into a unique rendition of an architectural form. See how imaginative you can be: create a composition using either a city skyscraper, like New York's Chrysler Building, or a church steeple or an Egyptian pyramid for a subject. Work out a series of studies before you start to paint.

Materials:

Canvas, 30" x 24"
Full palette of colors
Assorted brushes

The pyramid shape should be the central form on your canvas. You can, like Delaunay, break up the space around it in an abstract way. To achieve a more dramatic effect, use an above-eye-level angle. Next plan where your extreme lights and darks are to be distributed and superimpose any architectural details over this light–dark arrangement.

The next step is to plan your color scheme. This, of course, will depend on what time of day or night you wish to portray. If you're planning a scene at night, select colors that fall into a minor-key range, such as dark greens, violets, grays, and blues; for any lighted windows use a yellowish white. If your painting is set in a sunny day, use high-key colors to express the light, such as yellows, violets, light grays, greens, or oranges. For any recessed windows or doorways use darker versions of the same colors. Any further additions are up to you, depending on what mood you're planning to express.

Remember our motive in this project: to turn a triangle into a form that has volume, a pyramid shape, in an interesting composition.

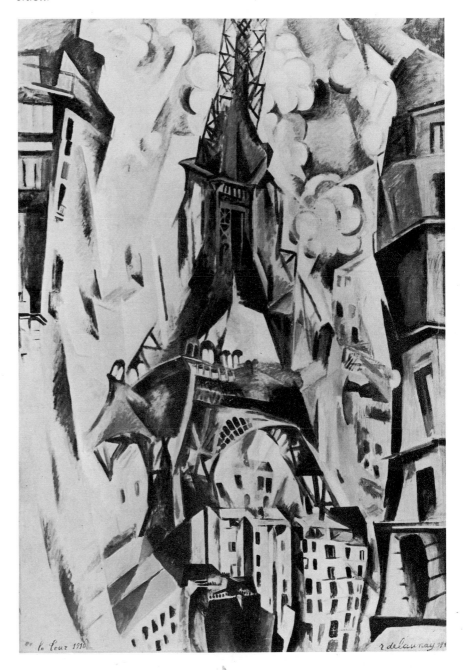

Robert Delaunay: Eiffel Tower, *1910.*
Oil on canvas,
59⅝" x 36⅞".
The Solomon R. Guggenheim Museum, New York

26. All Together in a Cityscape

In this project we're going to fill up the compositional space with facets of the three basic shapes that we've been involved with in the preceding projects. We're not going to be too concerned with the volume of these forms, however. Instead, we'll be thinking in terms of a flat overall pattern-like effect, suggesting deep space with the directional action of the forms themselves.

For your subject, think of a typical street scene that you feel excited about—I'd suggest an actual place that you're familiar with. In the painting reproduced here, the circle, the square, and the triangle have been juxtaposed to render linear space. This painting, without being too dependent on what the real scene is like, seems to express the essence of it in terms of the basic shape of each architectural feature. The Ferris wheel is round; the boardwalk is reduced to an oblong ramp; the flashing beacon lights are a triangle; the stairways are parts of cubes; and the highway on the left becomes a device for indicating depth. All sorts of reflected lights, including the moon, add up to a lively rendition of time and space in a picture that stands still. For this painting I made a series of sketches of the scene—a deserted Coney Island on a late fall day—and when I returned to my studio I started work on the large canvas. For your painting, I think you should follow the same procedure and see what happens!

Materials:
Canvas, 28" x 40"
Full palette of colors
Assorted brushes

Remember, the purpose of this exercise is to make an abstract rendering of a real scene by reducing all the forms in the picture to their basic geometric silhouettes. One advantage of this method of working is that since you're not concerned with a photographic rendering of the subject, you'll have much greater freedom to control the compositional space. You'll be able to use forms that work well together and are to your personal liking.

After making a series of preliminary sketches in which you've used actual scenes for a frame of reference, select the one you're most pleased with. On a separate sheet of drawing paper make an abstract version of it. Be as objective as possible, and try to eliminate all the non-essentials. Then take what's left and see each object reduced to its basic round, square, or angular counterpart. The composition should be planned so that there's one shape that creates the climatic area; all the other forms should play a secondary supporting role. Place this climatic area in a spot where it will stay put and not lead the viewer's eye outside the limits of the composition.

Your next step is to redraw this final version of your scene on the canvas, following your sketch as closely as possible. Now paint an undertone over the entire canvas, using one of your cool colors—a mixture of Prussian blue or raw umber will do. Study your composition to see if your main form is occupying the key spot. Place the other shapes in supporting positions, and plan the distribution of all the extreme dark-value colors so that they, too, will support your main theme. Start working with the dark values first and gradually progress toward white.

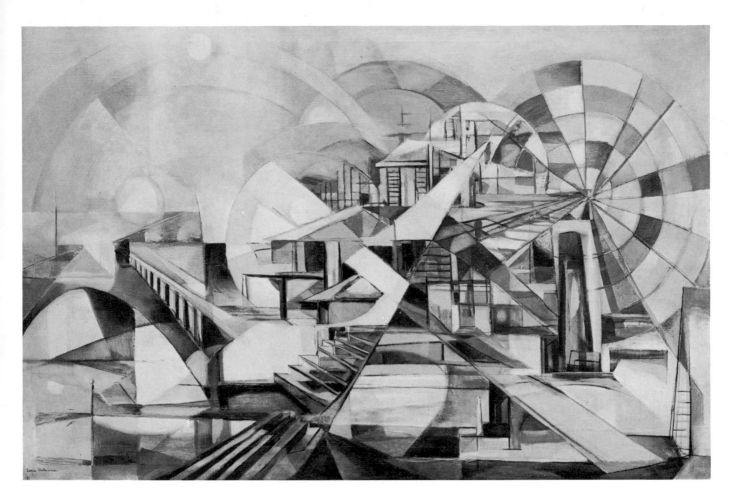

Lucia Salemme: Coney Island, *1965.*
Oil on canvas, 34" x 52".
Collection of the Artist

27. All Together in a Portrait

This project suggests how to abstract a portrait by breaking down forms to their basic geometric counterparts. The reproduction of Fernand Léger's painting accompanying this project is a fine example of what to strive for. The arresting face, painted in light tonalities and placed in the prominent top center of the canvas, acts as a magnet toward which the viewer can focus most of his attention. Because the forms are sharply delineated, their dark edges and stark contrasts create a rhythmic and dynamic design. Even though these areas are painted in dark-value colors, they nevertheless remain exciting because of the forceful design. They play a subordinate role to the main idea, however, which is the stark white face of the model.

Since we're dealing with shapes that aren't readily visible in reality, I suggest you first make an accurate rendition of a posed model. Follow this by making an abstract variation of your first sketch: simplify all the body contours and facial features in terms of the geometric shapes they resemble. For instance, the face is round, the nose triangular, the eye elliptical, and so on. Use your knowledge of the cubist approach to guide you.

Materials:

Canvas, 24" x 30"
Full palette of colors
Assorted brushes

Select a model that you find interesting. Pose her in a manner that will set off the volume of her form. I suggest you place a spotlight overhead so the light casts a sharp, direct glow on all the projecting features, as this device will make it easier to see the basic forms of each part of the body. Now study Léger's painting and see how he utilized only the essential forms and eliminated all unnecessary details. Try to do the same in your painting. Take time in planning your composition and make several preliminary sketches of your model.

Now plan a secondary compositional motif. You can have your model holding some object, or one that repeats your main idea but on a smaller scale in a less prominent part of the canvas. Select the sketch you like best and paint it onto your canvas, using a thinned wash of one of your neutral colors. Decide on what mood you wish to have your model express and select a color scheme that you feel will best do this: high-key (light and bright) colors for joy; low-key, restrained colors for a pensive poetic mood. By combining both you'll achieve an almost limitless variety of expression.

Plan to paint the compositional areas, using as little modeling as possible. Work with flat, untextured brushstrokes that won't interfere with the purity of your abstract forms.

Fernand Léger: Woman Holding a Vase.
Oil on canvas, 57⅝" x 38⅜".
The Solomon R. Guggenheim Museum, New York

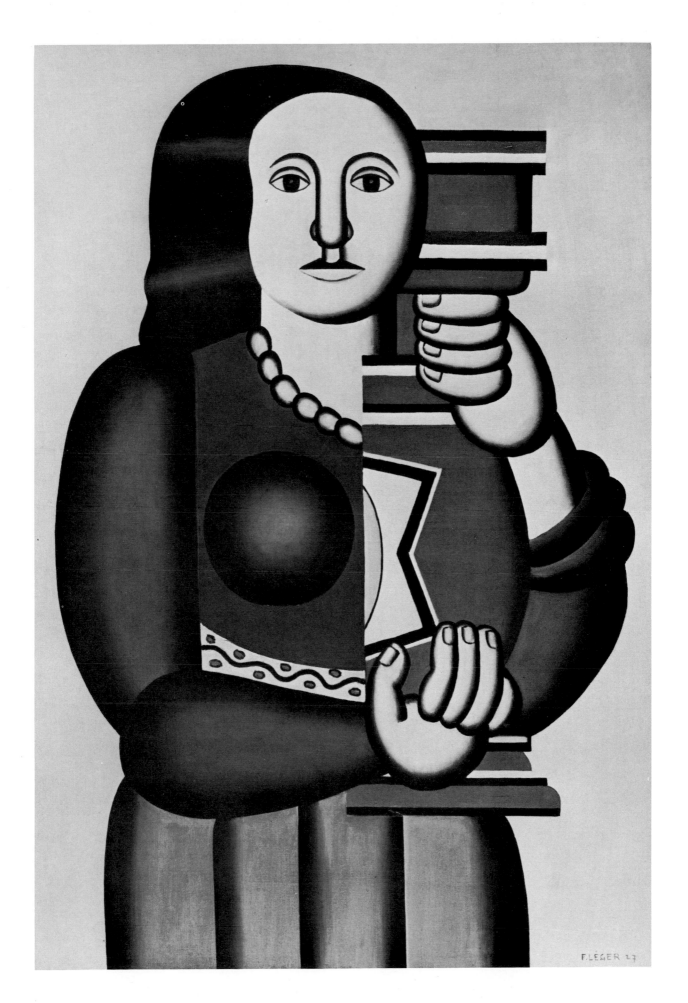

28. Disproportionate Volumes

In this project you'll learn to juxtapose three-dimensional shapes of different sizes to establish a feeling of visual equilibrium. To achieve this, disproportionate volumes must counterbalance one another. In this way, they'll hold together within the compositional space.

Picasso aptly demonstrates this idea in the beautiful painting shown here, expressing how the emotional content of subject matter combined with the perfect placement of all compositional elements can create an effect of balance and harmony.

Pablo Picasso:
Two Harlequins.
Oil on canvas, 59⅝" x 36⅞".
National Gallery of Art,
Chester Dale Collection,
Washington, D.C.

He's achieved this effect by placing forms of different volumes in balance to one another. The upright figure on the right is balanced by two shapes—the still life group on the window ledge and the bent figure of the boy—on the left. The harmony produced by these balanced yet disproportionate volumes is further emphasized by the artist's suppression of detail. In addition, the entire canvas is painted with muted colors. This, combined with the gentle facial expressions of the two youths, produces a serenity that leaves the viewer free to enjoy the beauty of the flawless composition.

Study this painting and then proceed to develop a picture of your own. Instead of people as subject matter, try using still life objects of disproportionate volume.

Materials:
Canvas, 30" x 24"
Full palette of colors
Assorted brushes

As a first step, collect a group of objects of different sizes. For example, take a very tall wine bottle and place a small open book near its base. Rest these items on a low table, so that only part of the tabletop is visible. On the wall behind the bottle, sketch a solid form—a hanging picture, a shelf, or even a window—to balance the bottle and the book. Select whatever form appeals to you most, just as long as it balances whatever you've placed on the low table.

Next, make a series of sketches to explore the different arrangements of your disproportionate forms. Select the arrangement that appeals to you most and redraw it on your canvas. Place your canvas in an upright, vertical position; you'll find this will provide the most interesting shape on which to arrange your diverse forms.

Whatever objects you include in your composition, render the volume of each. The best way to render volume is to have a definite source of light focused on your objects. Anything round, such as an apple or a melon, should suggest a solid bounded by a uniformly curved surface; the wine bottle, bounded by a circular base, with its body extending upward toward the narrow top, is basically a cone shape. The table is a cube whose base, sides, and top have different flat surfaces. These objects should supply you with many interesting shadow areas.

PART FOUR
VALUES

29. A Mood of Mystery with Halftones

When you're planning a painting where minor-key values are to be used, your palette will consist mainly of halftone versions of all the pure colors. A halftone is a middle value or a grayed-down version of a color. When a little black is mixed into a pure color—red, for example—it becomes a subdued red and is referred to as a red halftone. In this project, where you'll be concerned with projecting a mysterious mood, the halftones will play an important role. For a subject, try doing a self-portrait. Arrange the light in such a way that you get some exciting shadow areas on the face and shoulders.

Let's look at Rembrandt's well-known self-portrait. Observe what's referred to as "the Rembrandt lighting," that is, the kind of light that comes at a 45° angle from above and the side, causing the nose to cast a sharp shadow. The light on the right side of the nose casts a reflected light onto the right cheek, forming a triangular patch of light. Try it and study the result for yourself.

Materials:

Canvas, 20" x 24"
Full palette of colors
Assorted brushes

In doing a self-portrait, you'll of course have to use a mirror. Stand so that a good light is focused on you, creating interesting shadows on the face. Remember that the source of light is one of the major problems that must be resolved right off. If possible, choose a north light. This light lasts longest, is free from changing shadows, and affords the best opportunity for studying subtle tonalities.

Make a careful contour drawing of the head and shoulders, using a neutral color. Then mix a large amount of a good flesh tone. A basic flesh tone may be mixed with a substantial amount of white, some Naples yellow, and a little alizarin crimson. Carefully paint in the middle-value areas of all the facial planes by adding a little ultramarine blue to the flesh tone mixture. Then paint in the very dark areas of the face, using a mixture of raw umber and ultramarine blue. The light areas are next: use the basic flesh tone. Finally, paint in the very light areas by adding pure white to the flesh tone color. You'll discover that if you work from the dark values toward the lighter ones, the light areas will take care of themselves.

Now paint in all the other areas. The background color is very important, as it sets the mood; so choose it carefully.

Your finished painting should be a poetic and mysterious rendering of a self-portrait.

Rembrandt van Ryn: Self-Portrait.
Oil on canvas, 36¼" x 29¾".
National Gallery of Art, Widener Collection, Washington, D.C.

30. Gay and Happy Mood with High-Key Values

In rendering a gay and happy mood the subject of course always comes first. Next in importance is your choice of values, which should always be high in key. The term "high key" refers to colors that reflect the most light, such as very light versions of yellows and reds. Small doses of pale violets and greens can be used for shadow areas in a high-key-value painting. They also bring an added sparkle to the light colors when juxtaposed with them.

Degas, with his famed pastels of ballet dancers, is the unquestioned exponent of gaiety. For your painting, select a subject that expresse gaiety for you. You may also wish to use dancing figures, or perhaps you could have your figures frolicking on a beach.

Materials:

Sheet of pastel paper, 18" x 24"
Set of soft pastels (assorted colors)
Tortillon
Can of spray fixative

When working with pastels, you'll be using compressed, powdered pigments in their purest state; the powder contains no addi-tives. The technique itself is one of super-imposing one layer of pure colored powder over another, working always from the lighter colors toward the darker ones, building textures as you go along that have a velvety, peach-skin smoothness. After sketching in your subject with a neutral color (light gray, for example) apply a white ground to each area that is to be colored. Start at the top and work down to avoid smudging. Apply each successive color layer, keeping control of your values at all times so that they remain clear and light in value. Save the background areas for the last, using them to delineate your images and to act as accents for the pictorial idea.

Now that we've looked at the techniques of pastel painting in this brief summary, we can proceed to the structural part of the composition. To express gaiety, position the forms so that they describe a series of arabesques—the actions of the figures should convey a feeling of grace and buoyancy. This idea also applies to the negative space that surrounds the figures.

Edgar Degas: Dancers in Green and Yellow (Four Dancers).
Pastel on paper, 36¾" x 26⅜".
Courtesy of the Thannhauser Foundation,
the Solomon R. Guggenheim Museum, New York

31. Calm and Serene Mood with Light Gray Values

Lucia Salemme: Portrait of Claire.
Oil on canvas, 30" x 24".
Collection of Mr. and Mrs. Samuel Polk, Eastchester, New York

In this project we'll paint a portrait subject that expresses a calm, serene mood. Let's study the painting reproduced here. The pretty girl in the white dress is posed in a calm setting with no elements in the composition to distract. The artist has captured a serene atmosphere with a fluid application of subdued colors, using smooth brushstrokes on the face, chest, and arms. For the dress, both light and heavy strokes were used depending on the area. A breath of color, a bold penetration, a lyrical flow —these nuances of subtle white and grays are interwoven throughout the composition. The soft, light gray-value colors help project the strong character and personality of the subject. For your painting select a model with a calm personality; have her wear garments light in color and made of a soft fabric. Pose her in a relaxed, uncomplicated setting.

Materials:
Canvas, 30" x 24"
Full palette of colors
Assorted brushes

Make a careful drawing of your subject on the canvas, with the background spaces showing little or no activity. The light should be evenly distributed, casting diffused shadows. Paint in the large areas of background and the model's garments first, as these areas set the mood.

Next, mix a middle-value flesh tone. Apply a thin coat of this, and while it is still wet work white into the areas that are catching the light. Add a little ultramarine blue to the flesh tone on the shadow side of the face and arms. Use smooth brushstrokes. Work a little of the background colors into the light side of the face, using your judgment as to the amount you add.

Your finished painting should project a calm, serene mood.

32. Tranquil Mood with Dark Gray Values

The purpose of this project is to create a feeling of tranquility by using colors that are of a minor-key value. As in most paintings, the subject is important: if you wish to project a mood of tranquility, select a theme that suggests this idea to you. A still life subject can always be adapted to specific moods, so it might be a good idea to use one for this project.

Let's look at the tranquil painting reproduced here. This poetic canvas was painted in 1945, at the end of W.W. II. The artist has chosen a muted palette of blues and grays to express a tranquil and sober mood. The light is evenly distributed over the strange landscape, which is painted in rich, warm, darkened versions of his colors.

For your painting, where you'll also be expressing a tranquil mood, select a variety of still life objects that appeal to you. Remember: the mood of tranquility will be mainly set by the muted colors that you paint these objects in.

Materials:

Canvas, 18" x 24"
Full palette of colors
Assorted brushes

Arrange the objects on a table and have the light coming directly from above, as if from a skylight. First prepare your palette, mixing darkened vesions of all your colors by adding a little raw umber and some black to each. Now sketch in your compositon and paint in all the large areas first. These will set the mood you're interested in expressing.

Next paint in all the areas that are in the light. Then paint in their dark sides. Go after a gentle transition between light and shadow areas.

As a final step, paint in all the details. Your finished canvas in muted-scale colors should project a tranquil mood.

Attilio Salemme: The Final Victory.
Oil on canvas, 25" x 15".
Collection of Lucia A. Salemme, New York

33. Ominous and Foreboding Atmosphere with Chiaroscuro

The term "chiaroscuro" literally means light-dark. This sharp contrast of tonal values is a device many artists resort to when they wish to express dramatic atmospheric effects.

Caravaggio is one of the great masters of chiaroscuro—as a matter of fact the term is almost synonymous with his name. In his fine painting shown here, the effect more than speaks for itself. Notice how the stark whites are set off by the dark shadows within the composition. There are very few middle tones, and these play a minor role in the overall tonal value of the painting.

In planning a chiaroscuro painting of your own, first think of a definite dramatic idea. Caravaggio's ominous and foreboding mood is expressed, first, by the gestures of his figures and, second, by the dramatic placement of his dark and light areas. As a suggested subject for your painting, think of a group of figures watching a burning building or standing on a rocky shore during a storm. Limit your palette to black and white, using only red and yellow to render the middle values.

Materials:

Canvas, 24" x 30" or larger
Ivory black
Zinc white
Cadmium red
Lemon yellow
Assorted brushes

First draw several preliminary sketches on paper, dramatically distributing all your dark areas and dark forms. Have a definite underlying plan that will exactly express your foreboding mood. Decide where the climatic area is to be and use it as the center around which the other forms revolve. (In Caravaggio's painting the climatic area is the tabletop and the bent figure handling the coins.) Arrange each figure so that it creates a continuous motion that leads to the climatic point, whether it's a burning building or a stormy sky.

Select your favorite sketch and redraw it onto the clean canvas. Start to paint the areas immediately surrounding your center of interest. These should be the lightest in value. Use attention-getting light colors such as white, yellows, and oranges for the closest forms; paint those in the distance with dark grays or black. Work in tonal sequences—light toward dark—going toward the edges of the canvas.

As a final step, add color in any open areas to connect the separate parts of the composition. These won't disturb the strong pattern already made by the interplay of the extreme darks and lights.

Michelangelo Caravaggio: The Calling of Saint Matthew.
Oil on canvas, 10' 9½ " x 11' 5".
Church of St. Luigi dei Francesi, Rome.
Courtesy of Scala Fine Arts Publishers, Inc., New York

34. Warm and Glowing Mood with Light and Shade Values

The subject for this project will be a room interior having one source of light. You may include a figure if you like, but the main subject will be the inside view of a room.

Let's look at the painting reproduced here. A grand simplicity and style of execution is displayed in this interior by Vermeer. Each detail is perfectly positioned, and the entire canvas is flooded with the vivid effects of the light streaming in through the window. The background, painted with alternate variations of shadow passages, encloses the composition in a perfectly natural manner and provides an effective contrast to the light areas of the young woman's face and garments. The one source of light from the window, together with the shadows within the room, is what creates the warm, glowing, pulsating-with-life mood that permeates the entire painting. Try doing a painting of your own that expresses this same mood.

Materials:
Canvas, 18" x 24"
Full palette of colors
Assorted brushes

For your subject sketch a room in your own home that you're particularly fond of. Of course a knowledge of perspective is necessary in rendering an interior that may include doors, alcoves, arches leading into other rooms, floors, ceilings—and most important, windows. Then there'll be furniture, drapery, pictures on the wall, and chandeliers to consider. So plan your composition carefully, using only what's necessary. Select the best view of the room. Imagine you're inside a box: the vertical lines remain vertical, but the horizontal lines will slant downward if you're looking up (ceiling) and upward if you're looking down (floor). Once you establish the angle of the slanting ceiling and floor lines the rest will easily follow.

Next establish where your light is coming from. The loveliest light source is always a window light (as in Vermeer's painting), coming from one side and casting definite shadows in the opposite direction. Light from one side only is always more intense, producing stronger shadows. You'll notice that lights and shadows will overlap into one another, creating interesting patterns on the walls, ceilings, and floors. Observe them and select those you like best for your painting. Light is always stronger near its source; the darks are deepest in the farthest corners of the room. Sketch in your center of interest. It can either be a still life setup on a table, an armchair in the corner, or a figure posed at the window. The choice is up to you. Paint in all your details carefully. A warm and glowing mood should pervade the entire canvas if you've observed the above suggestions.

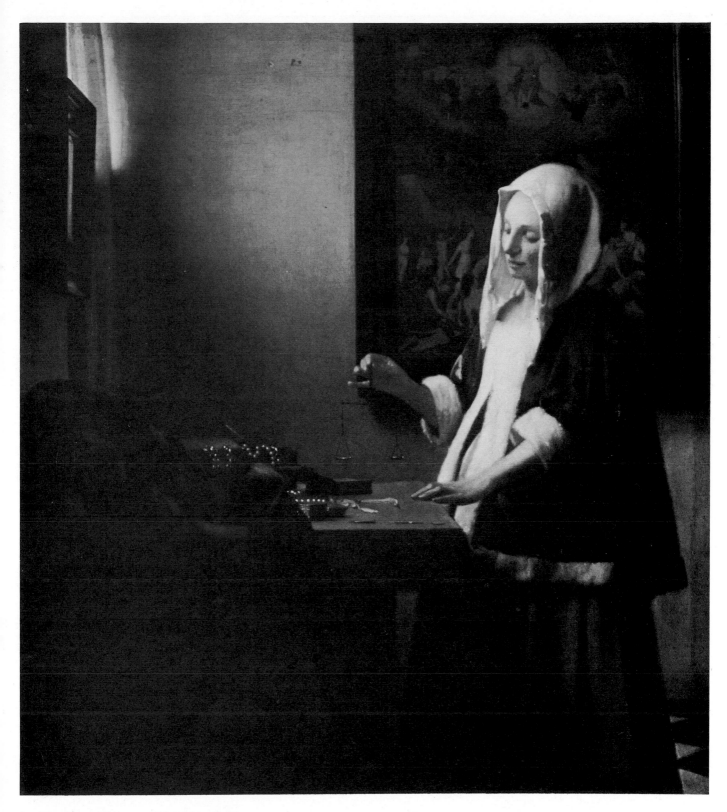

Jan Vermeer: A Woman Weighing Gold.
Oil on canvas, 16¾" x 15".
National Gallery of Art, Widener Collection, Washington, D.C.

35. Poetic Atmospheric Effect with Graded-Scale Values

In this project we'll paint a subject that will enable you to study the effects of shadow and sunshine in an atmospheric rendering of a seascape. We'll use graded-scale values to show a slow transition from the darks into the light areas.

A fine example of this idea is shown here in Turner's painting of ships at sea. The broad and luminous spaces of sea and sky are skillfully rendered, and his rich tones and subtle gradations of light and shadow creat the flamboyant atmospheric effects that he's noted for.

For your subject, I suggest you think of a remembered scene of a seascape, one that deeply inspired you at the time you saw it. It should be a scene enabling you to play with the effects of combined shadow and sunshine. Think of a specific time of day—morning or early evening—and work up a scene showing a sun-pierced, misty sky. You may wish to work directly from a scene, rather than try to remember one. If this is at all possible, do so. Make several small studies with pastels or water-colors. Select the best one and paint a large version of it in your studio.

Materials:

Canvas, 24″ x 30″
Full palette of colors
Assorted brushes

Sketch your subject and paint in the values, using grays made from black and white mixtures. Use very thin applications of paint so as to better achieve your gradations. Establish your lights and shadows .

Now, while the paint is still wet, brush appropriate colors into the different picture areas. Work blues and greens into the darkened water; yellows, crimson, and white into the sunset sky. In short, employ your knowledge of color to further express your ideas, as the value scale has already been determined with your underpainting.

The last step is to paint in whatever details are necessary to complete your statement recalling an inspired scene. The total effect should be a most successful expression of poetic, atmospheric feeling.

Joseph Mallord William Turner:
Junction of the Thames
and the Medway.
*Oil on canvas,
42¾″ x 56½″.
National Gallery of Art,
Widener Collection,
Washington, D.C.*

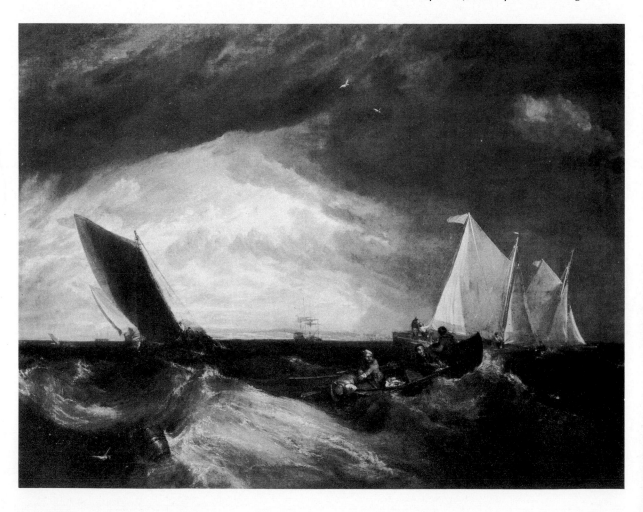

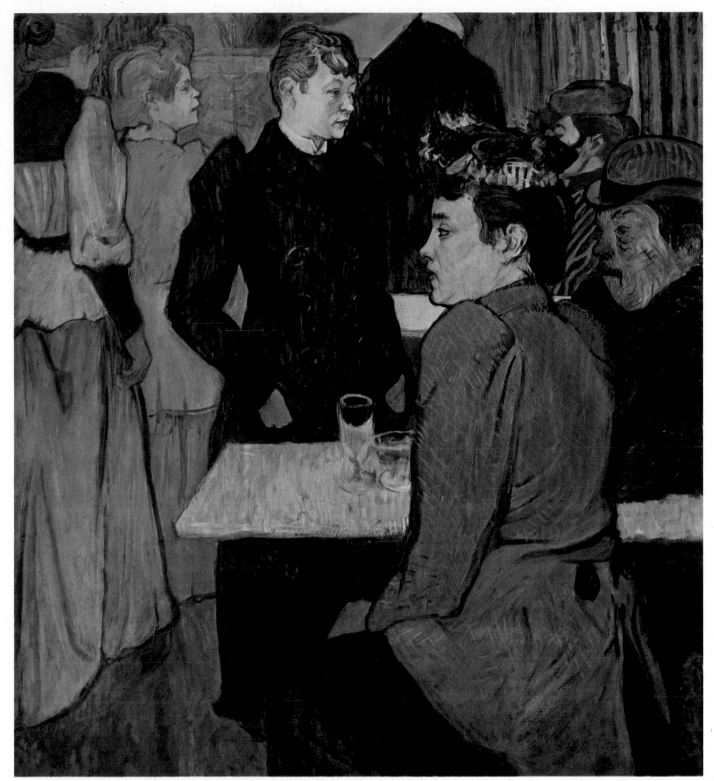

Toulouse-Lautrec: A Corner of the Moulin de la Gatte. Oil on canvas, 39½" x 35⅛". Even though the positions of the figures vary, the spatial break-up is even, making the verticals and the horizontals all of the same proportion. No attempt has been made to show perspective, and the result is a static rendition, as if the figures were frozen in action. The figure standing in the center, painted in a dark-value color, becomes the focal point to which all the other forms relate. The arrangement of the forms produces an overall sense of equilibrium and harmony. The artist has further stressed this harmony by using a series of analogous colors—predominantly blues and greens—and strong vertical thrusts of the figures with the counterbalancing horizontal slab of the table. National Gallery of Art, Washington, D.C.

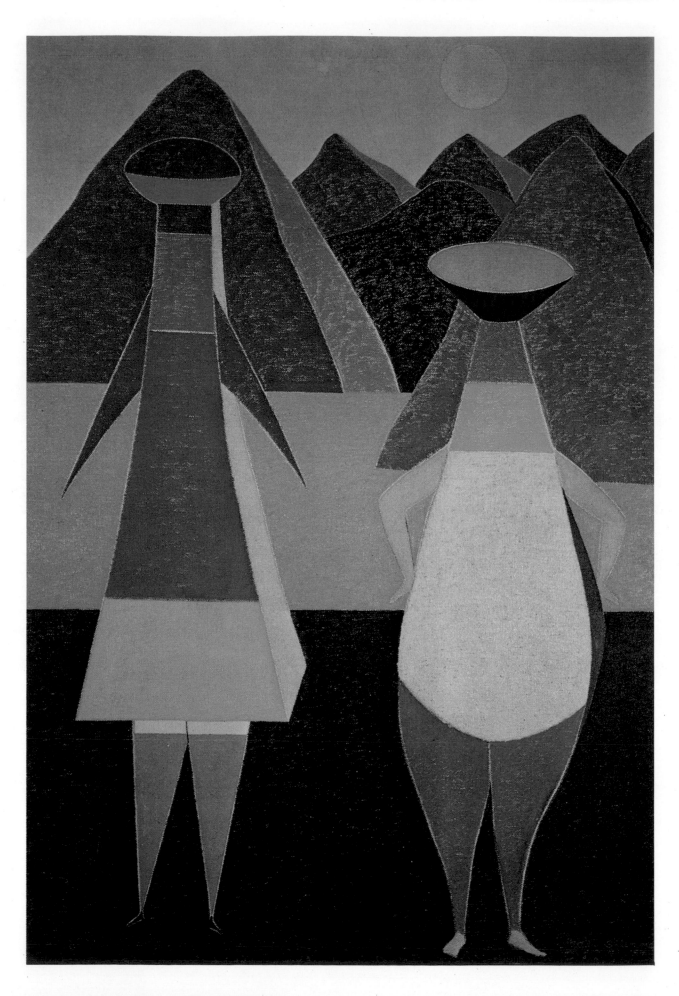

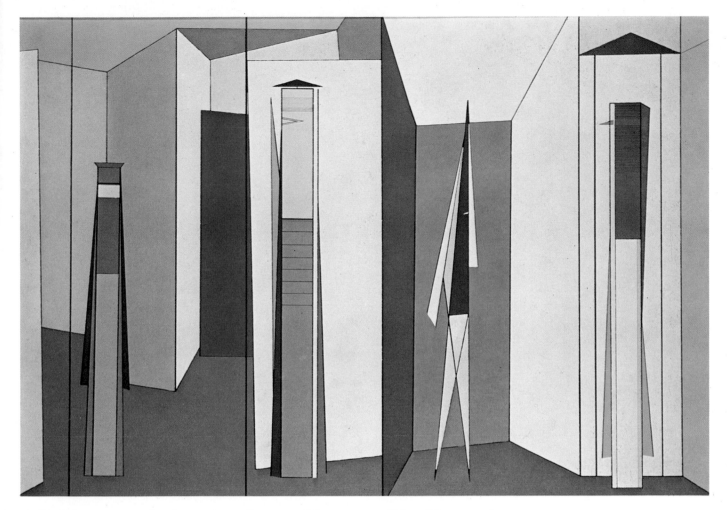

Attilio Salemme: Antechamber to Inner Sanctum. *Oil on canvas, 28" x 40".*
This painting is an excellent example of how a feeling of dynamic tension can
be achieved through the juxtaposition of forms and the use of stark, flat
color. The abstracted figures silhouetted against the pure colors of the walls
produce an unearthly "going-into-and-behind-one-another" suggestion of
activity. The placement of the figures; the clean, sharp outlines; the feeling
of space provided by the colors, the advancing and receding planes, and the
use of linear perspective—all these work together to produce a composition
alive with a taut and vibrant interaction of forms. Museum of Modern Art,
New York

Attilio Salemme: Adam and Eve. *Oil on canvas, 30" x 20". In this painting,*
color is used to create visual perspective. By keying all the colors up to their
clearest contrasts, and by using subtle juxtapositions to their complemen-
taries, the viewer is made acutely aware not only of the forms themselves
but of the spaces and volumes between them. The warm reds and green
blues in the figures make them seem to be advancing; the neutral blues and
grays of the landscape make it appear to go back even though the forms
are large in size. An overall luminous effect is achieved by the off-white
color of the canvas that shows through the brushstrokes, making these light
areas part of the total atmosphere of the composition. Private Collection

Titian: Diana. Oil on canvas, approx. 40" x 60". The sensual freedom of the Venetians is typified in this famous painting by Titian. His mastery in rendering delicate, soft-tinted flesh tones in a twilight-hour light—the hour when the landscape loses color while the flesh tones retain the light and breathe with its glow—is beautifully demonstrated. The goddess Diana reclining against the somber shadows in the room conveys an attitude of luxurious repose that creates a horizontal action in the composition. All the forms, including the figure of Cupid, are of almost the same proportion and are placed in perfect pictorial balance. This, added to the distant landscape reflecting the light of the luminous flesh tones, produces a mood of sublime calm and serenity. Capodimonte Museum, Naples. Courtesy of Scala Fine Arts Publishers, Inc., New York

Jan Vermeer: Girl with a Red Hat. Oil on canvas, 9⅛" x 7⅛". The arresting face of the young girl, painted in subdued tonalities and placed in the very center of the canvas, acts as a beacon that generates a mysterious and impassioned appeal toward the viewer. The background is painted in minor-key colors and acts as an outline for the face and the brilliantly colored red hat. The strong reflected light on the right side of the face separates it from the background and helps create the mood of mystery and romance that this famous painting is noted for. National Gallery of Art, Andrew Mellon Collection, Washington, D.C.

Alexander Calder: Mollusks, 1955. Oil on canvas, 30" x 40". This beautiful abstract composition aptly demonstrates how pure, amorphic, nonobjective shapes can be arranged in an uncluttered composition to express a balanced sense of order. The composition is subtle, the feeling of balance achieved by the sensitive placement of forms and by limiting the palette to just four colors—red, blue, black, and white. An element of surprise is produced by the juxtaposition of the different shapes and in Calder's use of color, adding to the lively suggestion of weight already evident in the forms themselves. The result is an exhilarating arrangement of delicately balanced forms of different weights. Courtesy of Perls Galleries, New York

Joan Miró: Personage. Oil on canvas, 40" x 30". In this unusual painting, Miró's fantasy world provides the spectator with several fascinating images that provoke different meanings at different levels. It's not necessary that we interpret them; they have a life of their own. He places his private symbols on a field of beautifully graded color. The images are moving around a limpid, red heart shape suspended from a string attached to a very solidly painted ball floating firmly above it. Miró clearly demonstrates his superb mastery of compositional space break-up in the way the forms balance each other in exquisite arrangements on the open surface of the canvas. His images are painted in flat, bright colors. The details are done with hairline applications of black, making lines that are the calligraphic identity of his ideas. His images are gay, yet mysterious, as they move together within the confines of the composition. Courtesy of Saidenberg Gallery, New York

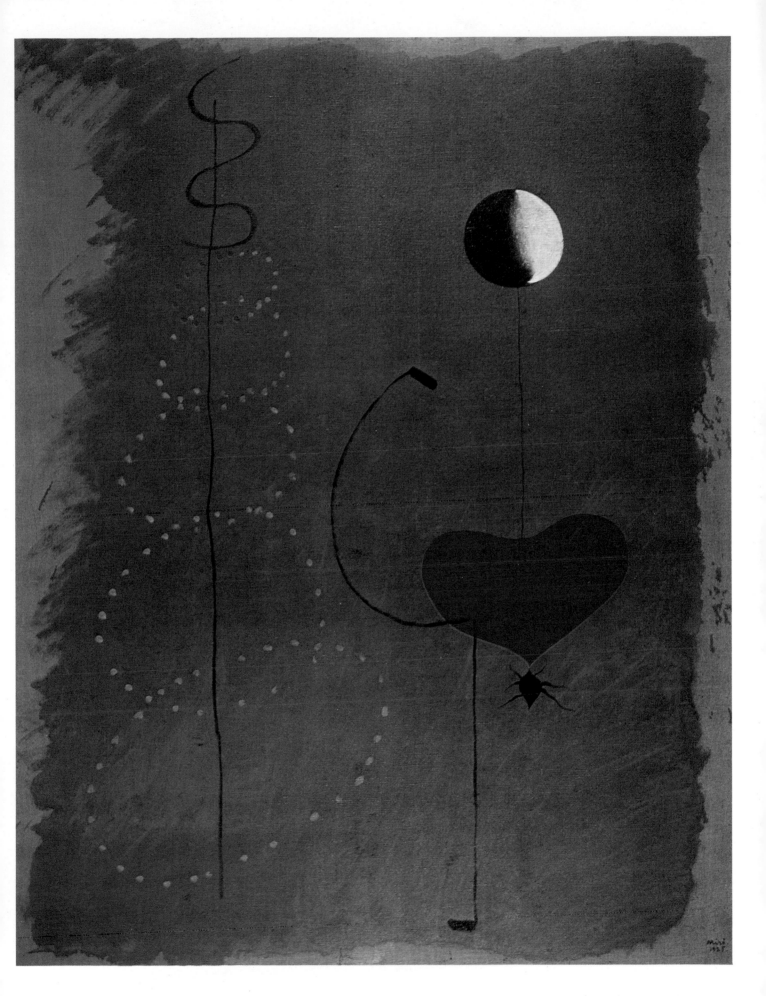

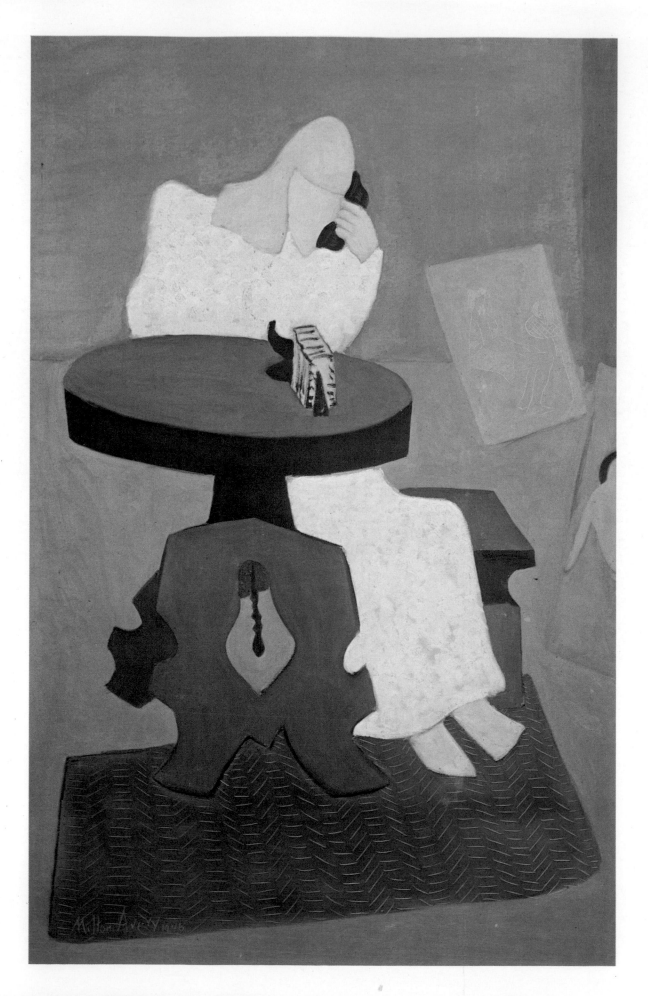

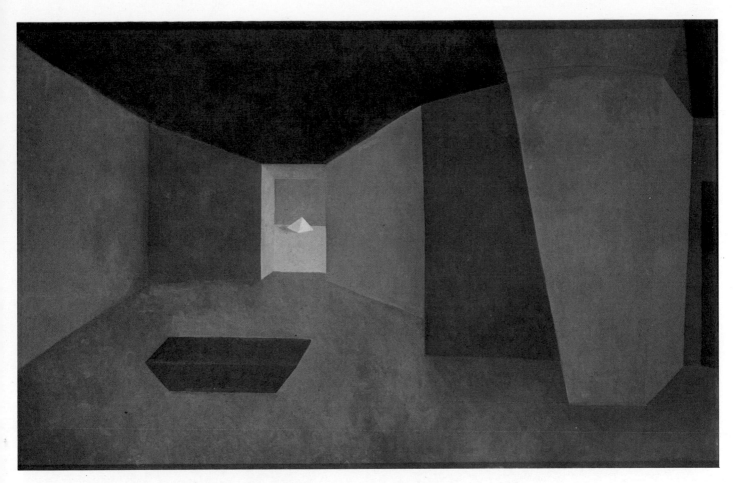

Attilio Salemme: The Womb of Time. *Oil on canvas, 32" x 50". The artist has used two focal points in this painting, permitting the viewer to penetrate the picture plane on two levels. The first focal point is the white pyramid silhouetted against a sky of celestial blue seen through the open door. The second focal point is the black box in the center of the floor in the room interior. The strong walls and floor of the mysterious room, painted in subdued earth colors, provide the link that connects the two focal points. The use of color also adds to the drama of the composition: the pure, clear colors of the scene on the other side of the door bring to mind the sky, high clouds, far-away vistas—infinity; the black of the box, on the other hand, is ominous, heavy, perhaps frightening. Collection of Dr. Graham Hawks, New York*

Milton Avery: Morning Call, 1946. *Oil on canvas. In this compactly composed painting, the artist has skillfully demonstrated his talent for capturing an underlying essential mood, for arresting movement so the viewer sees the essence of a moment in time. The young girl seated at a very solid table and deep in conversation on the telephone conveys a mood of complete concentration. The white-clad figure and furnishings in the room are treated as patterns, beautifully placed in harmonious arrangements and painted in the lyric colors for which Avery is so well known. Collection of Joseph H. Hirshhorn, Greenwich, Connecticut*

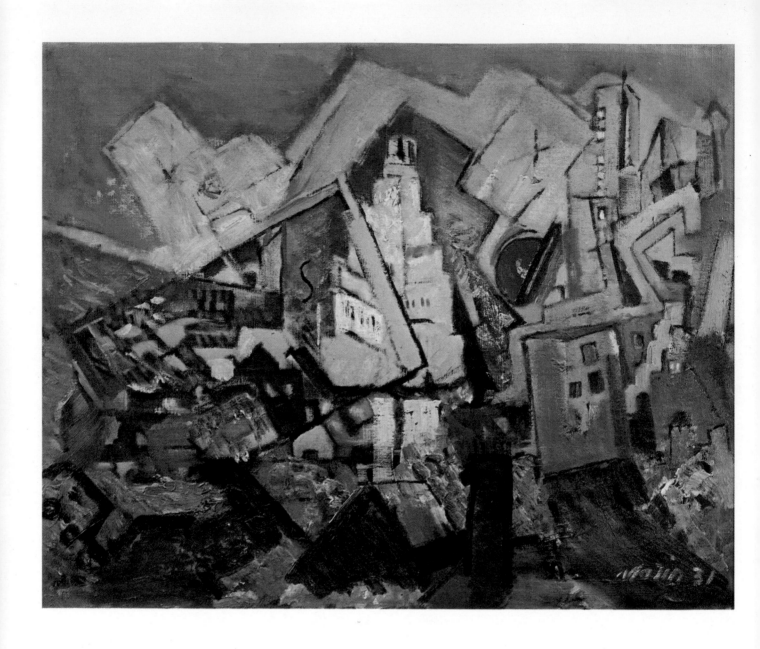

John Marin: Lower Manhattan at the Tip End. *Oil on canvas, 22" x 27". Marin's marvelous canvas, painted with surprisingly cool and muted colors, is an aerial view of the New York of the Twenties. The composition is built on a geometric pattern of angular shapes, so that the viewer's eye is ever shifting, resulting in a gentle dispersion of the pictorial elements as they revolve around the red half-sphere of the sun. Broad, direct brushstrokes define the silhouetted skyscrapers, zigzag lines, synchronized with the livelier passages around the buildings, express the quick tempo, the noise, and the vitality of Manhattan in its early stages of jangling activity and excitement. Private Collection*

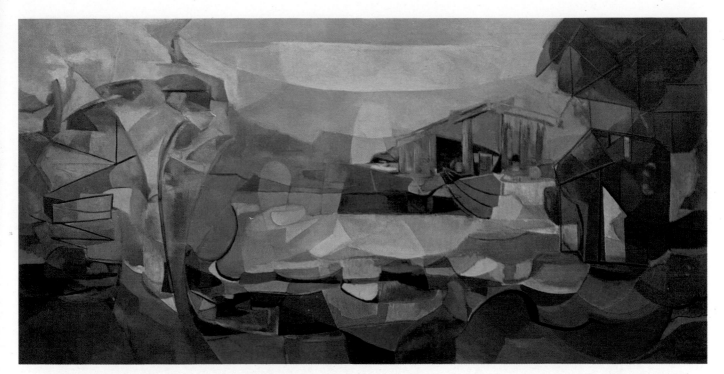

Lucia Salemme: Between the Moon and the Sun. *Oil on canvas, 54" x 108".*
In this painting, tangible images have been abstracted in a landscape com-
position. Each image has been transformed into the geometric shape it
suggests: angular areas represent buildings, triangles suggest foliage, cone
shapes bring to mind mountains, and cylindrical shapes convey the feeling
of pillars or tree trunks. The large canvas is divided into three sections, each
painted in one of the three primary colors—yellow, blue, and red. Each of
these three color sections serves as the field of color on which the individual
pictorial elements, painted in a variation of the same color, are superim-
posed. Thus, each section becomes an enclosed unit containing a family of
similarly colored elements, providing a series of three "one-color-at-a-time"
compositions. The three sections of the composition are tied together by
the linear, undulating rhythms of the horizontal shapes in the foreground.
The result is a startling array of lustrous colors in an abstracted version of
a classic landscape. Collection of the Artist

Paul Cézanne: The Clockmaker. *Oil on canvas, 36¼" x 28¾". Cézanne has*
created tensions between the different planes and masses in this composition
by having the color, forms, and lines mutually affect each other. Altering
any one of these parts would disrupt the chain reaction of their movements.
In the portrait reproduced here, the form of the seated clockmaker is a
deliberately controlled, sober study of a serious man. Cézanne has used
strokes of juicy oil paint to reveal the brilliance and vitality of his colors to
their fullest, juxtaposing the values so that their light and dark placements
form interrelated patterns. This back-and-forth pull that one feels in his
work is the invisible force that we mean when we use the term "plasticity"
in describing a painting. The Solomon R. Guggenheim Museum, New York

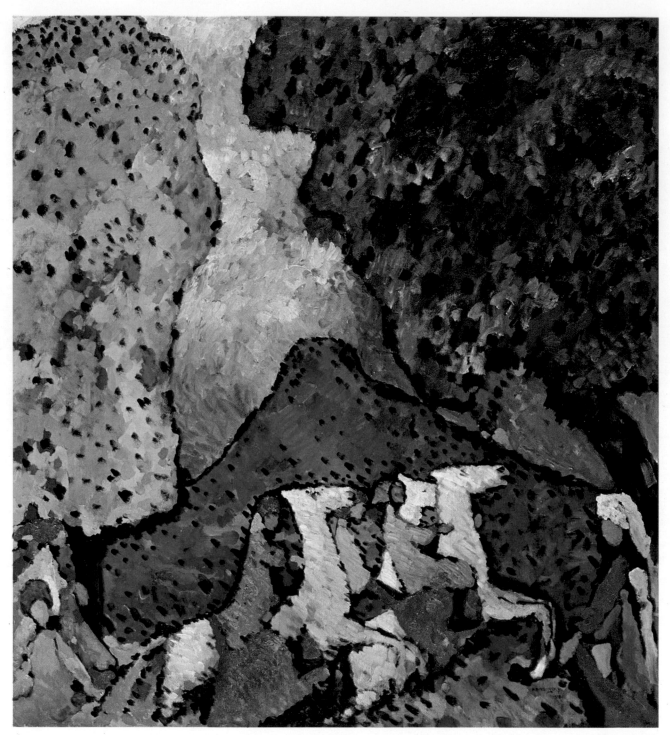

Vasily Kandinsky: Blue Mountain, No. 84. *Oil on canvas, 42" x 38½". Kandinsky has achieved a compositional unity in this painting by keying all the colors at their highest intensity, an effect he's heightened even further by juxtaposing his primaries in the large picture planes. The textures are carefully painted in what appears to be a modified version of the pointillist technique, and one is aware of the textural quality of each element. The sky is painted with smooth applications of color, so that a nebulous atmospheric effect is achieved. The blue mountain, outlined with a tremulous black edge, is painted with a faintly visible brushstroke, as are the horses and their riders. The autumn foliage is painted with thick splashes of pure color, interspersed with bold black dots. All this results in an intense study of nature that expresses the feeling of different individual textures while at the same time forming an overall pattern of the scene. The Solomon R. Guggenheim Museum, New York*

Lucia Salemme: Neon Night. Oil on canvas, 48" x 72". In this painting, the framework of the buildings has been exposed, revealing tense whirlwind forces in movement. When studied separately, each form appears static, but because it's placed next to a related form, a series is created as each form anticipates and moves into the next. It's the juxaposition of all these related forms in the composition, with each picking up where the other leaves off, that creates the feeling of flowing, continual motion. The completed picture expresses a mood of vibrating visual energies, stretched in a supreme effort of controlled tension and movement. Collection of the Artist

Pieter de Hooch: The Bedroom. *Oil on canvas, 20" x 23½". This painting is an excellent example of how contrasts between various tonal values in a compactly composed linear composition can create a glowing rendition of three-dimensional depth. The brightly painted garden seen through the open door supplies a welcome glimpse of the world outside the room. The interior is a repetition of a rectangle within a rectangle that divides each panel into progressively smaller ones of varied proportions. The room, with its earth-colored walls and furnishings, is given an added warmth from the glowing amber coming from the window and focusing on the standing woman. In contrast, the child at the open door, because she is getting the strongest light, becomes the focal point of the composition. The total effect is a rendering of perspective with a harmonious blending of line and contrasting tonal values. National Gallery of Art, Widener Collection, Washington, D.C.*

PART FIVE
SPATIAL RELATIONSHIPS

36. Overall Pattern

The purpose of this project is to do a painting with an atmospheric setting in which all sense of specific drama is eliminated. In other words, to produce a composition in which all the images occupy the same amount of pictorial space to create an overall pattern.

In the painting shown here, the artist has created an integrated whole by incorporating the details of his seascape into the other pictorial areas of the picture. Going one step further, he's used the white of the paper to act as one of the colors. The small specks of white paper sparkling throughout the entire picture surface are an integral part of the composition and further enhance the feeling of unity. All the elements—sky, clouds, sailboats on the water, and the shoreline—are ingeniously interwoven so that the completed picture is of an overall patterned seascape, more abstract than figurative.

Materials:
Canvas, 20" x 24"
Assorted brushes
Cerulean blue
Titanium white
Ivory black

For a subject, imagine lying on your back under a large tree and looking up at the foliage silhouetted against the open sky. Observe how the light of the sky shows through, making a pattern of leaves and branches. Plan your painting by carefully incorporating the open spaces that show between the leaves, making these openings part of the pictorial design, as Prendergast has done with the specks of white paper in his painting.

Carefully sketch the linear pattern made by the branches and the different leaf patterns, leaving open spaces for the sky areas. Now prepare your palette by mixing a range of at least five different grays, using different amounts of white and the black together. Add a little cerulean blue to each gray mixture: this blue will not change the value, but it will add a poetic atmospheric effect to the grays. Paint in your forms in whatever arrangement suits you, and you'll find that you've created an overall pattern.

Maurice Prendergast: St. Malo.
Watercolor, 13½″ x 20″.
Courtesy of the William Zierler Gallery, New York

37. Emphasizing the Climactic Area in a Portrait

In a portrait, the "climactic area" is the eyes. On first viewing your model, every aspect of her face seems important, especially if there's something unique about the features: the nose may be tilted, the mouth a rosebud shape, or the cheekbones very prominent. All these are important for rendering a likeness of your subject. But the eyes are the soul of the face, to which all the other elements in the portrait play a secondary role.

Leonardo has placed the eyes of the beautiful *Ginevra* in the painting shown here so they're almost in the center of the composition. Notice how the mood of quiet awareness and concentration is intensified by the subtle manner in which the contours of the eyes are delineated. The gentle depth of the pupils creates an uncanny three-dimensional effect. Another series of planes frames the face, further adding to the spatial depth of the picture: first a halo of lustrious hair, then, in the background, a mass of dark foliage which recedes into the gently painted landscape. Even though every facet of the painting is beautifully and sensitively painted, the eyes are the compelling focal point, the "climactic area" of the portrait.

Let's put this to the test and paint a portrait. You don't have to be an old master, you can be as free and loose in technique as you wish, just so that you keep in mind that the eyes are to be the climactic area of the composition.

Materials:

Canvas, 20" x 24"
Naples yellow
Alizarin crimson
Ultramarine blue
Burnt umber
Cadmium red
Viridian green
Cobalt violet
Titanium white
Ivory black
Assorted brushes

First make a series of preliminary sketches, posing your model differently in each one. Select the pose that permits you the greatest leeway in expresing your feelings. Seat the model so that the spatial planes of the face and shoulders counterbalance the spaces you've planned for the background. Next, transfer the best of your studies onto the canvas, using burnt umber thinned with turpentine.

Now mix a flesh tone. Since there really is no such thing as a "flesh tone," the one you mix will depend on the colors in the model's immediate vicinity, which will reflect on her skin. You can mix a basic tone by combining titanium white wth Naples yellow and a drop of alizarin crimson. This mixture makes a reasonable middle-value flesh color into which you can safely blend additional colors. Add white to this mixture for the highlights; for shadow areas, add a bit of ultramarine blue.

Now you're ready to start painting. First the eyes: be careful not to cover the lines you've previously sketched onto the canvas. Concentrate on the color values. Notice how *Ginevra*'s eyelids are a lighter value than the "whites" of her eyes. You can try getting the same effect in your painting by showing a marked contrast between the two areas. So as to better control shadows, always bear in mind where your source of light is. Paint in the darks, then the lights.

Now plan and paint in the background areas, that is, those areas that play a secondary role. By more or less subordinating all the other areas in the composition to the model's face, the eyes should become the climactic area of your portrait.

Leonardo da Vinci: Ginevra de Benci.
Oil on wood, 15⅛″ x 14½″.
National Gallery of Art, Washington, D.C.

39. Positive Spaces

What we call "positive space" is the area in the composition made up of solid shapes —that is, the shapes that have volume.

We have a splendid example of this important compositional aspect in the handsome self-portrait reproduced here. The main positive shape is that of the man. He looms largest and is placed directly in front, with his wife approaching him from the garden. The other positives are the brilliantly colored bird, the still life objects, and the textured drapery behind the left side of the man. The atmospheric effects are created by the negative spaces that surround the very solidly painted positive shapes.

Try painting a canvas of your own containing several positive shapes. For instance, three figures standing at different points in the composition, with atmospheric landscape images surrounding them.

Materials:
Canvas, 40" x 30"
Full palette of colors
Assorted brushes

Plan the compositional space break-up carefully so that there will be room for two or more people, each getting progressively smaller as they recede into the background landscape. Paint in the background first. Cover the entire canvas with a suitable mood color, and while the paint is still wet, work in whatever landscape images you like. Keep in mind that this is to be the negative space and that all the images should be suggested only minimally. The positive shapes, on the other hand, require a great deal of attention. Consider all the aspects that go into rendering them in dimension, such as source of light, the shadows they cast, the textures of their surfaces, and good draftsmanship.

Take ample time to paint this project: your reward will be in having painted a fine example of positive shapes dominating in a figure composition.

Sidney E. Dickenson: And the Myrtle Warbler.
Oil on canvas, 53" x 40".
Collection of the Art Students League, New York

40. Negative Spaces

The purpose of this project is to study the importance of negative spaces and the role they play in both creating an atmospheric mood and supporting the main subject in a painting.

You know that solid three-dimensional forms are the positive spaces on which all attention is focused in a composition; the spaces in between or behind these forms are negative spaces. These negative spaces would not exist were it not for the linear delineations of the positive spaces. Notice how clearly the artist has identified the negative spaces in the painting shown here, using a bold black edge to outline his subject. All the forms are painted in strong, dark lines. The negative space around and behind the linear motif plays a supporting role to the strong main forms, and it suggests a quiet atmospheric mood which beautifully demonstrates the importance of negative space. Let's concentrate on these negative spaces by doing a figure study, this time outdoors with a figure standing in a landscape.

Materials:

Canvas, 30" x 24"
Full palette of colors
Assorted brushes

As a first step, paint the entire canvas with a ground color to suggest the proper atmospheric setting for your figure and landscape. The solid form of your figure should of course occupy the main positive space. So plan to have the figure engaged in an interesting action. You could have him in the act of coming out of the water of a lake, for example. Sketch him so that he's large compared to the other areas in the composition.

Next, plan the landscape. Bear in mind that the landscape area is your negative space. Be very selective as to what details you use. Details should not be too boldly delineated: *suggest,* rather than *focus,* to make sure they remain in their proper negative role. Paint this area in gentle color tonalities, keeping the color scheme uncomplicated.

Remember, you're painting a scene outdoors. So, depending on the time of day it is, your palette should consist of a suitable light-key color scheme to express the light.

When you've completed blocking in all the areas with the colors of your choice, outline both the figure and whatever forms you've included in the landscape with a firm ultramarine blue edge. This dark blue outline will help separate the positive from the negative spaces.

Stuart Davis: Gloucester, 1932.
Gouache, 22¼" x 17¾".
Courtesy of the William Zierler Gallery, New York

41. Positives and Negatives Work Together

In this project we'll combine what you've learned in the last two exercises.

In the painting shown here, the artist has used a series of fragmented scenes of farm and country life. If you look closely you'll be able to identify them. They're composite views of different aspects in a landscape, fused together into an overall pattern. Upon checking more closely, one can see a series of events simultaneously taking place in a harmony of action, a kaleidoscopic vision of village life that creates a display of balanced harmony.

Materials:
Canvas, 18" x 24"
Full palette of colors
Assorted brushes

Since the negative space is the area that does *not* make a statement, but is actually the setting or backdrop for the positive spaces, it's a good idea to mix a suitable atmospheric color and then paint the entire canvas with it. The first step, therefore, is to select a color that will not be too in-trusive, one that tends to recede rather than advance—blue or green mixed with white and a little raw umber, for example.

Paint the entire canvas with this mixture, using smooth, untextured brushstrokes. Your negative space has now been clearly stated. While the paint is drying, make studies on a separate paper of the solid shapes you're planning for the positive space.

In Gleizes' painting, farm life is used as a theme, but you may wish to use city life as a subject in your painting. When your ground color has dried, superimpose your pictorial images in such a way that the ground color of your negative space shows through the positive areas that you've superimposed over it. You will be able to create another dimension simply by painting more heavily on each positive form to make it appear thick and heavy. In this way the negative space of the ground color will recede and the thickly painted positive spaces will come forward, making it easier to identify each area.

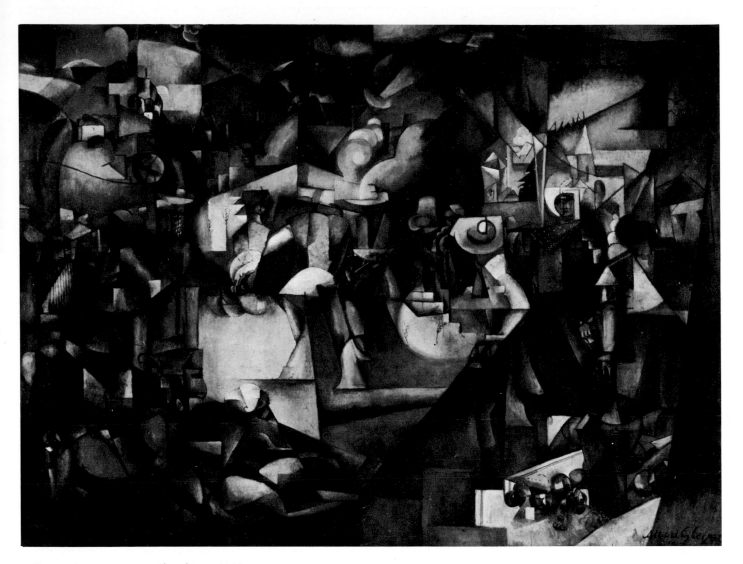

Albert Gleizes: Harvest Threshing, *1912.*
Oil on canvas, 106" x 138⅞".
The Solomon R. Guggenheim Museum, New York

42. Weight and Visual Balance

In this project we'll try to understand weight and visual balance. The best way to do this is to note that all suggestion of weight—that is, the feeling that areas are heavy or light—is rendered by painting these areas in an abundant variety of tonal values. Therefore, the value plan of your picture must be your chief consideration.

Let's look at Matisse's powerful painting shown here. He clearly demonstrates how different tonal values and a strong pictorial break-up of space can express weight and visual balance in a composition. By boldly planting the solid form of his model in the very center of the canvas, he's made her the core to which all the other pictorial elements must relate, thus establishing a logical feeling of balance. The model's back is superbly shaded so that a sense of volume is established, resulting in a firm expression of the weight of her seated body. At the same time, dark areas in the background balance the extremely light-weight tonal values of the figure, resulting in a dramatic, vibratingly alive composition.

Now let's go to work and plan a balanced composition in which the key elements that make up the pictorial structure are arranged so that they counterbalance one another. You must decide how you'll use your values. For a subject, you might select a scene showing a solid and heavily formed tree trunk combined with an array of lacy leaves, or a still life with a heavy vase surrounded by smaller, lighter objects such as filmy drapery and fragmented sea shells or a seated figure nearby.

Materials:

Canvas, 24" x 30"
Ivory black
Titanium white
Assorted brushes

Prepare your palette by squeezing out lots of white paint and a little black, side by side. Combine these to make a group of five different gray mixtures, placing the five mounds of these different grays on the top edge of your palette next to the pure black and pure white.

Next, sketch your main form (the one that has the most solidity) onto the key spot of your canvas, then place the other forms in an uncluttered arrangement around it. You'll find that regardless of their sizes, the forms will balance one another when they're painted in the proper values. A small black area, for example, will balance any large light area; a group of small dark gray shapes will balance one small white area. Try several experiments on a separate sheet of paper, juxtaposing the forms in different groupings, and select the one you like best for your painting.

Your picture will be balanced when each form seems essential and the elimination of even the smallest one would disrupt the continuity of the composition. Now paint in all your forms, using your previously mixed tonal values. To visually express weight and balance, the heavy forms should be painted in well-modeled grays; the lightest-weight areas should be left for your whitest values. Now paint your open spaces with a neutral light gray value. The last step is to put in whatever fine details are necessary for the completion of your statement.

Your finished painting should express a sensation of substantial solidity in a well-balanced composition.

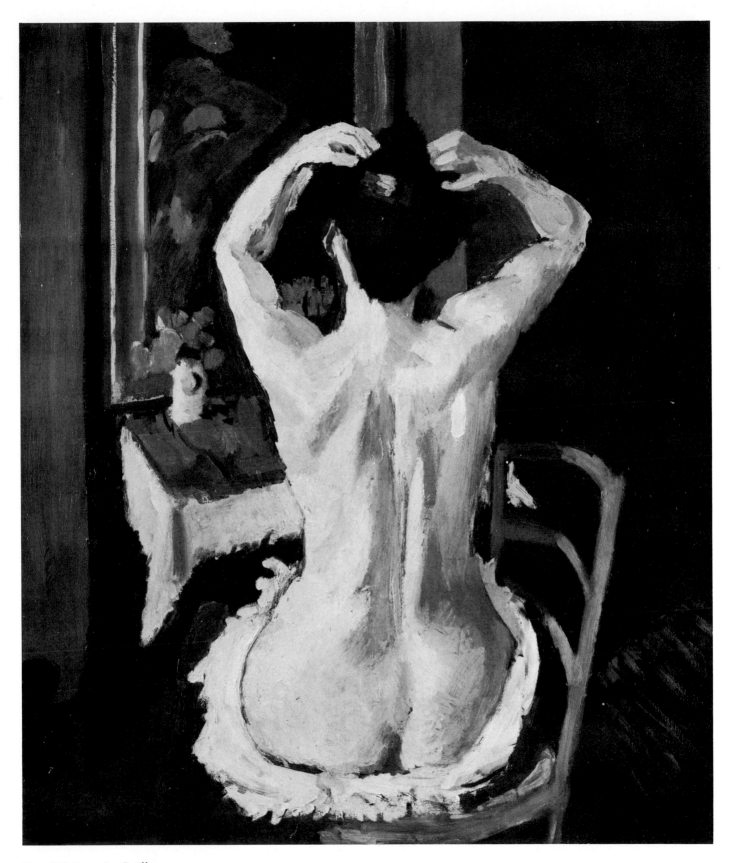

Henri Matisse: La Coiffure.
Oil on canvas, 37½" x 31½".
National Gallery of Art, Chester Dale Collection, Washington, D.C.

43. Shapes within Shapes

The purpose of this project is to do a painting that shows how compact and solid you can make a composition if you first use a form found in nature that you've abstracted down to its basic structural shape and then mold new shapes into it. The result is a composition made up of shapes within shapes.

Study Franz Marc's enchanting painting and note how his composition is basically built on round forms (with a few variations in the periphery areas of the landscape). Marc has placed his figures so that they form the nucleus about which all the other compositional forms revolve. The figures become shapes within shapes, which in turn create spatial energies that stretch and turn in a circular composition, giving the painting a taut, spring-like action. The figures are so well integrated into their surroundings that when the picture is looked at from a distance all the details and compositional elements seem to blend into one form.

In planning your painting, first think of an interesting shape that will act as the nucleus for your composition. As an example, let's think of an oval shape: a child asleep in its crib or a form in nature—a bird, for example. Surrounding the bird, you could paint its nest, and the nest, in turn, could be surrounded by leaves on the branch of a tree. This is just a suggested subject of course. The best idea will always be one that you think up yourself. Just remember to use shapes within shapes in your composition.

Materials:
Canvas, 18" x 24"
Full palette of colors
Assorted brushes

On a separate sheet of paper, sketch a series of imaginary forms that are all the same basic shape. These shapes should fit inside a similar-shaped larger one. One shape should act as the center of interest; it should be, in some manner, distinguished from the other shapes.

Now redraw this basic composition onto your canvas and develop it further by considering each of the shapes one at a time. As you paint them, think of the textures and apply the paint with its natural texture in mind. (Study Marc's painting and see how he treats the splashing waterfall.) Rely on the thickness of your oil paints to give an added dimension to your canvas.

Next, check to see if your brushstrokes are applied so that they continue the action created by your shapes. As a last step, put in your details. Your finished painting should demonstrate that when shapes of similar contours are placed within each other, they automatically create a sensation of solidity and compactness very pleasing to the eye.

Franz Marc: Waterfall.
Oil on canvas, 65" x 62".
The Solomon R. Guggenheim Museum, New York

44. Balancing Forms of the Same Size in a Landscape

The purpose of this project is to take shapes that are the same size and use the subject matter, and what each shape represents pictorially, to render diversity and balance. From having worked with shapes having the same size in a previous project (Project 2), you'll know that the usual effect is one of monotonous, static space. However, you can change this by having each shape express a different idea.

Let's look at Vlaminck's lively landscape. All the forms are almost exactly the same size, yet because the forms that occupy each of the spaces are uniquely different from each other, the resulting composition is full of delightful surprises. The cluster of houses forms the nucleus of the composition and is the heart of the picture. The houses are framed by a lovely windswept sky at the top and by a lustrously painted river and shoreline at the bottom. The trees on either side of the canvas complete the enclosure and add to the variety of pictorial images.

Materials:

Canvas, 24" x 30"
Full palette of colors
Assorted brushes

For a subject for your painting, a landscape would be a good idea. But start by making some good nonobjective sketches as the basis for your composition. And remember: all the areas must be of the same proportion.

After you've made several drawings, select your best sketch and redraw it on your canvas. Next, make a list of all the features that are characteristic of a country landscape: hills, rocks, lakes, houses, fences, trees. Then plan which of these pictorial ideas you will superimpose onto your shapes and spaces. Next mix and prepare the colors you're going to use and paint in all your middle-value colors. Apply all the extremely dark areas, leaving the lightest, almost white, areas for the last.

In the final stage of your composition, study what you've painted so far and eliminate any superfluous areas. Accent the necessary details by either using stronger color or cleaner delineation. Since the success of this painting depends on each shape expressing a different intellectual idea, it's essential that the details in each shape are clearly rendered.

Maurice de Vlaminck: Carrieres—Saint Denis.
Oil on canvas, 28⅞" x 36¼".
National Gallery of Art, Chester Dale Collection, Washington, D.C.

45. Reversed Images and Sharp Contrasts

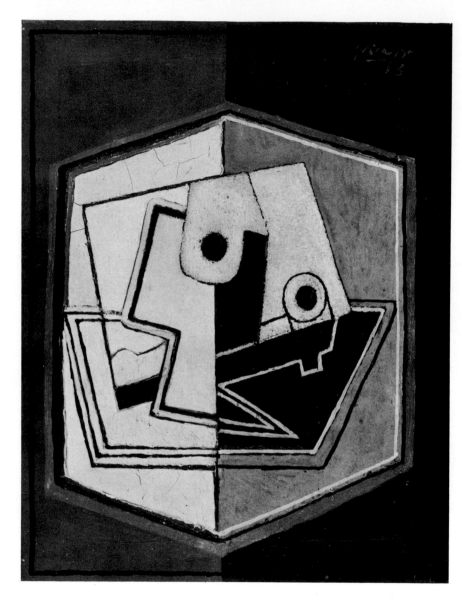

Pablo Picasso: Composition, *1918.*
Oil with sand on canvas, 13¾" x 10¾".
The Solomon R. Guggenheim Museum, New York

The purpose of this project is to demonstrate how balanced forms can show versatility in a composition if the main forms are reversed and set against each other by means of sharply contrasting color values.

The painting by Picasso reproduced here is a solid example of images showing perfect balance in a composition. The main forms are repeated in reverse images side by side, thus establishing a balanced orderliness. Picasso has further emphasized the feeling of equilibrium by using dramatic dark and light values in direct opposition to one another. By doing this, he not only gives each shape a distinct entity, but also gives the canvas an appearance of versatility which would otherwise be lacking.

The choice of subject will be optional in this project as I should like you to begin using your own imaginative skills at this point. Like Picasso, you may want to use abstract forms entirely. On the other hand, you may select something entirely personal. Whichever subject you decide on, however, keep the images uncluttered and as pure in contour as possible. Make several studies and then transfer the one you like best onto the canvas.

Materials:

Canvas, 24" x 30"
Ivory black
Titanium white
Cadmium red
Assorted brushes

As a first step, divide your canvas equally into two halves. Your dividing line may be upright, like Picasso's, or diagonal or horizontal. Next sketch in the forms you've decided on in the left side area of the canvas. To produce the necessary reverse images on the right side, just imagine what these same forms would look like if reflected in a mirror. When you've noted how the forms should appear, sketch them onto the right side. The composition should show perfect balance when you've completed your sketch, but not much of anything else. Paint each form in sharp contrasting values on each half of the composition to create interest and diversity. Remember, your main concern has been to create a composition showing reversed images in sharp contrast.

As a final step, check to see if the full canvas shows harmony and balance of evenly distributed forms, and whether the values were used to further accent your dark values and stark whites.

46. Undulating Forms Together with Rigid Shapes Express Grace and Energy

In this project we'll study how waving and curving forms create a feeling of graceful motion and energy in a composition. The images that immediately come to mind when thinking of undulating forms are those we associate with the world of nature: rolling hills, cloud formations, linear gestures of the human body, ocean waves. Combine one of these undulating forms with a rigid solitary shape and you'll create a feeling of grace and energy. Plan a composition, perhaps using one of the forms mentioned above, that expresses graceful energy for you.

Notice how in the Gauguin painting shown here the feeling of graceful and energetic motion is created mostly by the undulating, darkly painted trunk of a tree running across the center of the canvas. Actually, the whole composition pulsates with elasticity and life because Gauguin understood that undulating forms by themselves are tense, but that when they're next to an unattached, rigid shape, energy is created. Notice how undulating motion is expressed in the curved contours of the bathers, and the splashing wave next to the tree trunk; how energy is shown in the rigid form of the seated girl, and how, together, they produce a relaxed expression of graceful motion. As a subject for your painting, plan an idyllic landscape composition. Be sure to keep in mind that the curving forms need to be combined with rigid shapes if you expect to express graceful energy. For instance, for the curving forms you might use a frieze of gently rolling hills, and for the energy you might interrupt the frieze with the rigid shape of a rock or an upright solid tree trunk.

Materials:

Canvas, 24" x 30"
Full palette of colors
Assorted brushes

Make several preliminary sketches, blocking in all the planes. Plan the color scheme so that it supports the movement already established by the shapes. The color should stem from the nature source it represents. For example, blue for sky and water, pale earth colors for the rolling hills, green for the foliage. They'll enhance each other when in strong contrast: colorful modulations for the large undulating areas next to powerful flat colors for the rigid shape. Your larger expanses of undulating shapes will, as in Gauguin's painting, tie the composition together and the result will be a painting pulsating with graceful energy.

Paul Gauguin: Fatata te Miti.
Oil on canvas, 26¾" x 36".
National Gallery of Art, Chester Dale Collection, Washington, D.C.

47. Overlapping Forms Create Continous Movement

What better way to express continuous movement than to use human figures in an action composition! The purpose of this project is to use a group of interweaving shapes to show movement. For your painting, plan a composition that involves human forms in actions representing an event that you find interesting. It could be a group of people engaged in a sport event, dancers in a ballet, or a nonobjective composition using overlapping curved shapes.

But first let's study Ruben's superb painting. He has his figures engaged in the sorrowful act of taking the body of Christ down from the cross. The dead Christ is placed in the very center of the canvas; the figures supporting him form a circular pattern around him. The flowing movement of their garments are an extension of their extended arms and hands, all leading the viewer's attention back toward the limp body in the center. The swirling energies of the rounded figures and flowing garments create a continuous movement, a lively compositional style typical of the master's work.

Materials:
Canvas, 40" x 24"
Full palette of colors
Assorted brushes

For a painting of this kind it's necessary to make a good preliminary sketch in preparation for the final painting. Start by placing your main figure or shape in the center. All the other elements should revolve in a circular motion around this central form, assuring a forceful feeling of action. Keep any background motion quiet in order to calm down the turbulence created by the movement of your figures. If you're planning a nonobjective composition, your concept should be kept quite simple: you'll be using overlapping, abstract, rounded shapes only. If, on the other hand, you're planning to use the human figure, a knowledge of anatomy is necessary. You may have to study live models in action to get the correct poses. So plan on giving a great deal of time and attention to the preliminary studies for this project.

When you've arrived at a satisfactory study, transfer it onto your canvas and start to paint. Use thin layers of colors first to establish light and shade patterns, then build up successive layers of color until you're satisfied that the painting expresses continuous movement with overlapping forms.

Peter Paul Rubens: Descent From the Cross.
Oil on canvas, 45" x 30".
The Lee Collection,
Courtauld Institute Galleries, London

48. Horizontal Forms Express a Restful and Peaceful Mood

In this project we'll express a restful and peaceful mood by using horizontal action forms. All subject matter having horizontal actions and forms in their structure appear peaceful. This is evident if you look at the flat plains in a desert landscape, a city sky-line silhouetted against a spread-out sky, or a sleeping figure. The imagery should be personal: it's up to you to decide what kind of subject matter would best express a restful and peaceful mood in your painting.

Constable's fine pastoral landscape captures this mood. Study his distant horizon, the full-blown, luxurious trees, the spread-out pond, the grazing animals, and fence-enclosed pasture. All, including the cloud formations in the sky, stretch clear across the canvas in a totally horizontal action. After you've chosen a suitable subject of your own, plan the compositional break-up for your painting, keeping in mind that the horizontal shapes should dominate.

Materials:

Canvas, 20" x 40"
Full palette of colors
Assorted brushes

Make several preliminary sketches of your idea, always bearing in mind that the maximum feeling of restful calm is obtained when your main center-of-interest form stretches across the canvas while all the other horizontal forms in the composition lead up to the main one. The main horizontal form in Constable's painting is the long grove of trees running clear across the very center of the canvas. All the other idea elements progressively lead the eye into the horizontal back-and-forth rhythm of the composition.

You should now have a good, restful substructure upon which to build the paint textures. Apply the paint with horizontal brushstrokes and use colors suggestive of peace and rest. A muted palette of toned-down colors can be made by mixing each color with a little raw umber.

John Constable: Wivenhoe Park, Essex.
Oil on canvas, 22⅛" x 39⅞".
National Gallery of Art, Widener Collection, Washington, D.C.

49. Vertical Action for Majesty and Dignity

This project will show how a mood of great majesty and dignity can be suggested when vertical shapes dominate the composition.

Daumier has accomplished just this effect in his painting of two standing figures. Though interrupted by the horizontal action of the couch behind them, the upright action is nevertheless continued in the majestic and dignified feeling of the other elements in the composition that have an upright action—as in the row of pictures hanging on the wall. The poetic half-light that bathes the background wall adds to the dignified and sober mood of the scene, and is further intensified by the contrast of the extremely sharp light focused on the earnest faces of the young artist and his teacher.

For your painting you may wish to use a different vertical subject idea. One suggestion would be to do a nonobjective study made up of long vertical shapes standing alone. Or you could do a full figure portrait with the person standing upright in the very center of the canvas.

Materials:

Canvas, 40" x 20"
Full palette of colors
Assorted brushes

Plan your composition so the spaces behind your main figure (as in the Daumier) also assume a vertical movement. If you're painting a portrait, move the model so that she's in the exact center of the canvas: this placement will greatly add to the feeling of height already projected by the pose. You're now ready to start painting—but first choose an appropriate color scheme. Use light gray-value colors in the background sections, for example, saving the more dramatically accented values for the main subject. Use fairly visible brushstrokes that take a vertical direction in the painting. And finally, paint in whatever details that are needed to refine and accent your statement.

Your finished painting should be a fine example of majestic dignity in a composition made up of vertical action shapes.

Honoré Daumier: Advice to a Young Artist.
Oil on canvas, 16⅛" x 12⅞".
National Gallery of Art, Washington, D.C.

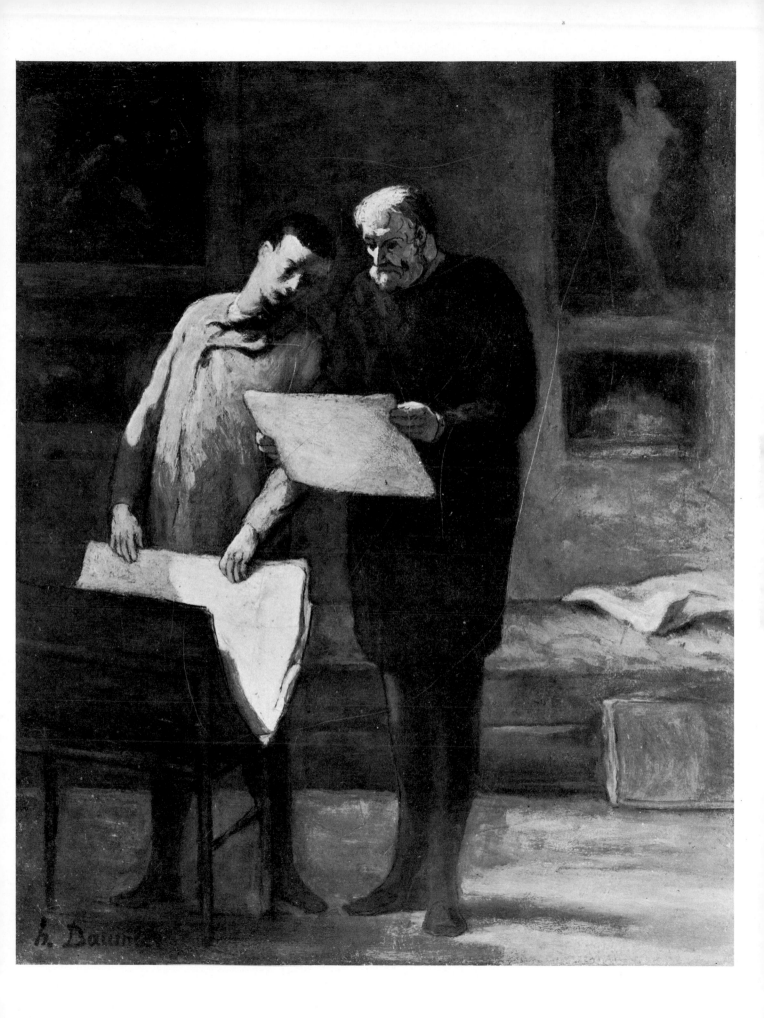

50. Oblique Action Forms for Dynamism and Speed

In this project we'll render the illusion of powerful movement by using shapes that have diagonal oblique action. When oblique forms and shapes dominate the design, they create a sensation of powerful movement in the direction toward which they incline.

This idea is beautifully demonstrated in the abstract painting shown here. The artist has used fragmented images that are characteristic of a stable and put them in a patterned arrangement that suggests stables and racing. The motifs include horses, fenceposts, stable doors, and horse stalls, all ingeniously centered so that the architectural forms create an oblique action, rendering the illusion of great speed and dynamic action.

Materials:

Canvas, 15" x 30"
Full palette of colors
Assorted brushes

I've suggested you use a canvas with long dimensions so that you'll be able to repeat your basic design; this repetition helps create the feeling of uninterrupted motion. As a subject for this project, think of a figure pushing a heavy object, or a strong tree being bent by storm winds, or any violent action.

After selecting a theme for your painting, make several preliminary sketches, then choose the best one to paint. Simplify all the forms in your composition down to their basic shapes—rounded edges for any animal or landscape shape, hard edges for architectural shapes. You may wish to refer to Marc's painting and study how he handled his motifs.

To express a sensation of power and motion, make sure all your forms incline sharply in one direction. Show sharp value contrasts in the selection of the colors: this will add greatly to the excitement and dynamism of your canvas.

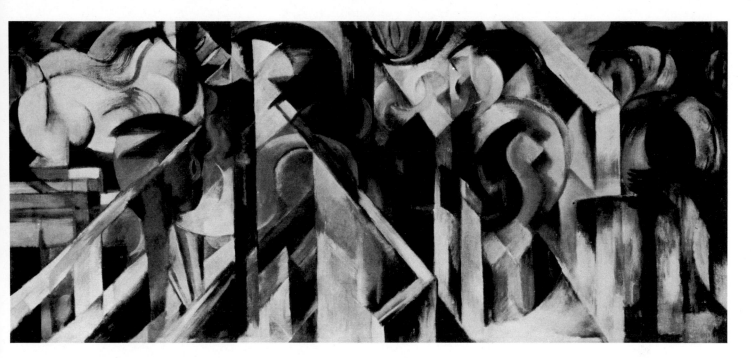

Franz Marc: Stables.
Oil on canvas, 29¼″ x 62⅛″.
The Solomon R. Guggenheim Museum, New York

51. Spray Shapes Create Graceful Movement and Gaiety

Unlike other action lines, the fountain spray motif is a form that suggests a gay and graceful movement, evoking a corresponding feeling in the viewer. In this project our purpose will be to use spray shapes in a painting to express a lighthearted mood.

Let's study Monet's lovely painting of water lilies. Note how the young petals seem to spring gayly yet defiantly from their source in the water; they seem to be in constant motion. Rhythmic brushstrokes create gentle circular movements in the water that echo the graceful movement of the plants.

For your painting, think of some delightful happening that you've witnessed: ballet dancers in action perhaps, or fireworks during a celebration, or fountains in full spray. Any carefree event will do, so long as the main image has a curved spray motif. After you've selected your subject, think of a suitable environment to put it in, as Monet has done with his water lilies.

Materials:

Canvas, 20" x 24"
Full palette of colors
Assorted brushes

In this project your choice of colors will help immensely in rendering a gay and lighthearted mood. I suggest you use undertones of all the primaries, giving you some pale yellows, pinks, and light blues to brighten your already delightful shapes. You might paint in a ground color first, then superimpose the spray-shaped image, painting with direct, spontaneous brushstrokes. Build the rest of the composition around the main shape, as Monet has done with his lovely pond. Finish your painting by refining the details with the darker colors.

Claude Monet: Fleurs Aquatiques.
Oil on canvas, 60" x 56".
Musée Marmottan, Paris

52. Fragmented Forms and Broken Lines Express Desolation

Not many artists wish to express a feeling of desolation in a painting, but there are times when this mood can be most poetic. In this project, we'll plan a composition of a "nervous" event. This event, or action, may be rendered with organic forms, as found in the world of nature—the barren branches of a burnt tree in a war-torn landscape for example—or in the form of a force of nature, such as a vibrating lightning bolt, fierce storm clouds, a tornado, or an earthquake. All of these would require the use of broken lines and fragmented forms in the composition.

Marc has done just this with his composite view of a desolate landscape, made up of segmented, sharp-edged fragments of mountains, partial views of houses, and half-starved animals. The composition is climaxed by the ominous bird of prey perched on a warped tree, calmly surveying the sad landscape. This may be a picture difficult to live with, but it's one worth remembering.

Try placing elements which to your mind create a mood of desolation in a painting of your own. Begin by making a few preliminary sketches.

Materials:

Canvas, 20" x 30"
Full palette of colors
Assorted brushes

Like Marc, you may wish to paint a landscape composition. Start by painting an undetailed, erratic pattern of hills and roads, then superimpose your smaller forms over this pattern, spotting the different images and leaving them isolated, not touching each other. Trees and plants provide ideal forms for this with their foliage outlines, stems, and branches. You may also wish to include people or animals, depending on your personal feelings. Any inclusion of linear forms next to the organic nature forms will accentuate the desolate mood. Superimpose sections of fences or telegraph poles to help create the nervous effect that broken lines always produce. Use subdued colors in the painting, such as grays and blues, with perhaps lemon yellow for contrast—and your painting expressing a desolate mood should be a success.

Franz Marc: The Unfortunate Land of the Tyrol.
Oil on canvas, 52" x 79".
The Solomon R. Guggenheim Museum, New York

53. Spiral and Twisting Actions Express Conflict

In this project we'll render a fundamental rhythm found in nature—the spiral—which is best observed in the writhing and twisting shapes of old trees, root formations, and in the gnarled structure of rocky hillsides.

Let's look at the turbulent painting shown here. The principal design in this composition is the spiral that Van Gogh uses frequently in a great deal of his work. For your painting you could perhaps do a study of an old tree, a subject in which the spiral and twisting action of a powerful, organic form can be put to full use.

Materials:

Canvas, 18" x 24"
Full palette of colors
Assorted brushes

Make several preliminary sketches, either from memory or from an actual tree. A tree without its leaves is best. Keep in mind that the shape of the trunk and the direction of the branches represent its journey through life, its struggle with the elements —storms, rainless summers, heat, frost— and its survival amid all these hardships. Therefore you can be as vigorous as you like in twisting the trunk and churning the branches, leaving the spiraling action for when you come to render the texture of the bark. It's not necessary to be too literal; you can achieve much of the textural quality with a palette knife technique, using generous mounds of paint for the rich impasto look which will add another dimension to the surface of the canvas.

The combination of twisting limbs and spiraled surface textures will give you a complete expression of the elements of conflict found in the world of nature.

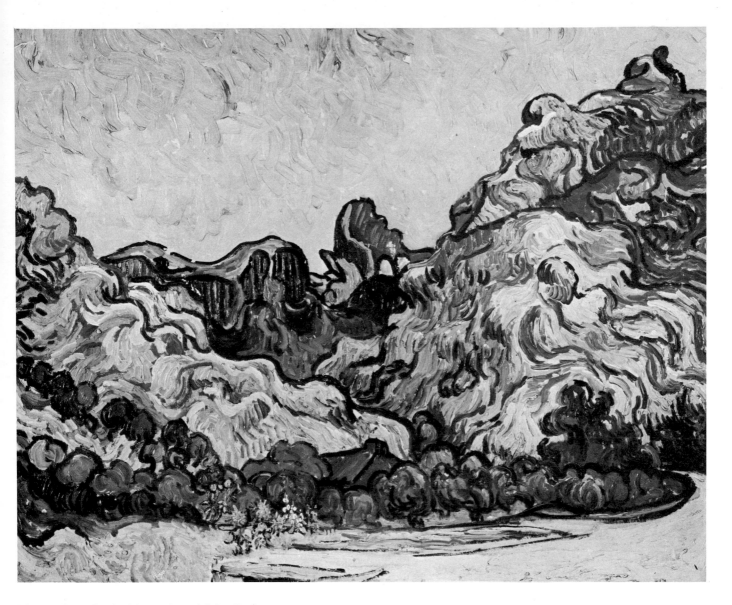

Vincent Van Gogh: Mountains of Saint Remay.
Oil on canvas, 29" x 37".
Courtesy of the Thannhouser Foundation,
the Solomon R. Guggenheim Museum, New York

54. Zigzag Movement for Excitement and Animation

The purpose of this project is to show excitement. This mood is best rendered with subjects composed of crowds or groups of objects, as these are inevitably in constant motion.

For example, visualize a crowded dance floor with people gesturing in animated dance, or a group of windswept trees in a storm, or a range of tall, jagged mountains.

Let's look at the painting reproduced here and note how the artist planned her compositional break-up by taking a group of houses, fragments of a street, a roadway, chimney-tops, and a bridge structure, and arranged them in what seems to be a haphazard way on the canvas. The arrangement is not really haphazard at all: actually the angle of each form was carefully planned. Notice how the canvas is divided in half, sectioned diagonally from top right to bottom left and the forms in the upper left area incline in an opposite direction than those on the bottom right. This opposite inclining of the shapes creates the animated mood expressed in the painting.

Select a subject that suggests the idea of excitement and animation to you and then plan to carry the idea out in a painting of your own. Remember: your subject should require the use of zigzag forms.

Materials:

Canvas, 18" x 24"
Full palette of colors
Assorted brushes

First make several thumbnail sketches of the subject you've selected. Arrange the shapes so that they incline in diagonals. The axis of each point of the angle must lean in an opposite direction to the one it's next to. You'll see the animated and excited effect as soon as you've blocked in the shapes.

Choose colors that will sustain the exciting mood established by your shapes. Have a strong chiaroscuro arrangement of values, as this too will add to the excitement. Top it all off with bright, high-key colors for the final touch.

Lucia Salemme: Journey of a Mood.
Oil on canvas, 22" x 34".
Collection of the Artist

55. Flowing Lines Express a Languorous Mood

In this project we'll render a languorous mood with flowing, rhythmic, action lines. The kind of movement produced by these lines is evident in studying forms in nature —the patterns of stones, the bark of trees, the sweep of sand dunes, the undulations of undersea plants.

Let's look at Munch's poetic lithograph. A symphony of languorous rhythms is created as the flowing tresses of the man and woman float about in the rolling waves of a gentle sea. The flowing lines provide the feeling of continuity necessary for creating a languorous mood.

In doing a painting of your own that expresses this mood, make a selection from one of the themes mentioned above and develop it in your own way. I suggest you make a black and white rendering of your subject for this project so as to concentrate solely on the linear structure of the composition.

Materials:

One sheet of good-grade all-purpose
 drawing paper, 18″ x 24″

Several sticks of soft charcoal
Kneaded eraser
Sandpaper block
Small can of spray fixative

Start by blocking in your main shape, placing it in a key spot within the compositional space. It will become the point of reference for all the other shapes and ideas in the picture. Munch placed his main idea on the bottom half of his canvas; you can put yours in a similar area, and as he's done, you can repeat the other flowing forms above and around it. In this way, they'll play a secondary role, supporting the original main idea while at the same time sustaining the languorous mood. As you're involved purely in a black and white rendition of the subject, use the full range of the black and white value scale. The more values you use, the more poetic your expression of a languorous mood will be.

When you've finished, spray your picture with fixative to prevent the charcoal from smudging.

Edvard Munch: The Lovers.
Colored lithograph, 12⅜" x 16⅝".
The Solomon R. Guggenheim Museum, New York

56. Pointed Figures Express Vivacious and Alert Tension

In this project we'll try to understand how alert and vivacious tensions can be established in a composition with forms that have pointed and hard edges.

In the painting shown here, all suggestion of movement—that is, the feeling that the forms are either rigid or flexible—is determined not only by the pointed contours of each, but in the walls showing through and between them. There's a logic to the space divisions. Note how the juxtaposed figures seem to levitate against the protruding walls to produce an unearthly suggestion of activity, as if they're in an atmosphere where there's no gravity. Tension is created by each of the pointed shapes because of the rigidity of their outside edges, and the manner in which the artist has divided his spaces creates added dimensions to the spirited pictorial atmosphere.

In doing a painting of your own, you may wish to paint an architectural scene showing cross-sections of skyscrapers that cast sharp, pointed-shape shadows, or a nonobjective, geometric composition with shapes that have sharp edges. Whatever your choice, bear in mind that the objective is to express vivacious and alert tension by keeping your forms pointed with hard edges.

Materials:

Canvas, 24" x 30"
Full palette of colors
Assorted brushes

After you've decided which subject you're going to paint, the one that best expresses alertness and vivacity for you, make a preliminary drawing using juxtaposed, hard-edged forms. Divide the spaces between them, such as shadows or open walls, so that they provide sharp contrasts and set each other off. The juxtaposed forms in the composition will create the feeling of tension. Use strong, dramatic colors, in sharp contrast, between all the picture areas and the sensation of tension will be heightened even further.

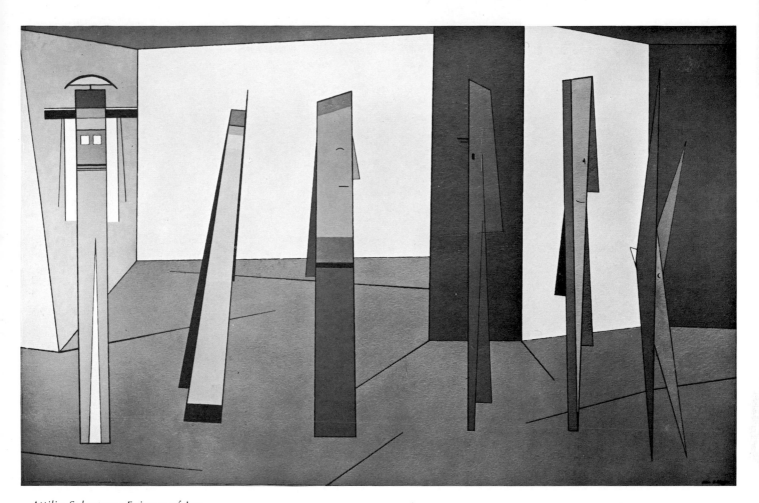

Attilio Salemme: Enigma of Joy.
Oil on canvas, 52" x 80".
Permanent Collection of the National Collection of Fine Arts,
Smithsonian Institution, Washington, D.C.

57. Broken Lines Express a Nervous and Excited Mood

In this project we'll render a nervous and excited mood by using repeated dots and dashes, broken lines, and color dissonances.

First let's study the painting shown here. The artist has created a vibratingly nervous tempo by skillfully spotting small windows in staccato-like arrangements and by scattering barren trees throughout the stark landscape. The pulsating sensation is further developed by placing very bright and very dark colors side by side.

A suitable subject for your version of a composition showing a nervous and excited mood might be a view of a city backyard.

Materials:
Canvas, 24″ x 18″
Full palette of colors
Assorted brushes

First sketch the outline of what you think a city backyard looks like. You may wish to depict the façade of just one building with trees, fences, windows, and fire escapes. Arrange these features in small, broken, pattern-like rhythms so that the interest is dispersed and spread over the entire canvas, with no one center of interest. Then select colors that are geared to produce dissonances when placed next to each other. For example, a light version of a color next to a dark color, or a primary next to a complementary color (light green next to dark red; violet next to yellow; orange next to blue). These color combinations will create the frenetic and vibrating sensation we associate with excitement.

Work quickly, and apply the paint in thick, impasto-like strokes. Your finished painting should express a nervous and excited mood.

Charles Burchfield: Hillside Homes, *1920.*
Watercolor, 25½″ x 18½″.
Courtesy of the William Zierler Gallery, New York

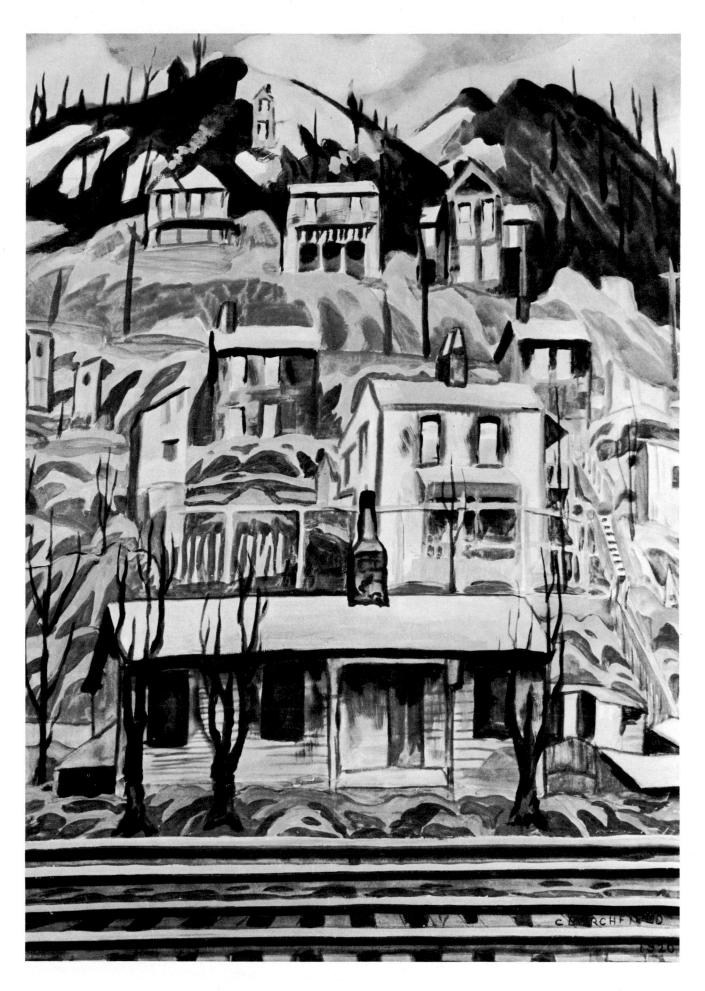

58. Diagonals Accent the Center of Interest

The diagonal line in a composition is usually used to suggest movement. However, when it's used with other diagonals, together they act as directional signals toward any spot in the composition to which you wish to call attention.

We see this aptly demonstrated in this painting by Renoir. The most prominent motif is the design pattern on the woman's gown and the diagonal lines reaching from opposite corners of the canvas toward the lovely face. These lines underscore the fact that the face is the main center of interest of the composition. There is also a secondary diagonal motif made by the slanted action of the seated man, which calls further attention to the lady's face. Just to be different, try a landscape subject for your painting, using diagonals to accent your center of interest.

Materials:

Canvas, 24" x 30"
Full palette of colors
Assorted brushes

Make several sketches of a landscape with four mountains, each a different height. Have a series of roads or ski slopes starting at the corners of the canvas and leading diagonally up the mountains to something interesting in the sky: a house at the top of the mountain, the sun, or unusual cloud formations. What the point of interest is doesn't matter so long as the diagonals point toward it. These lines will not only create movement, they'll become directional signals that will focus on your main idea. There are many kinds of brushstrokes you can use, but remember that diagonal-action strokes will speed the movement toward the climatic area of your picture.

August Renoir: La Loge.
Oil on canvas, 31½ " x 25".
The Lee Collection,
Courtauld Institute Galleries, London

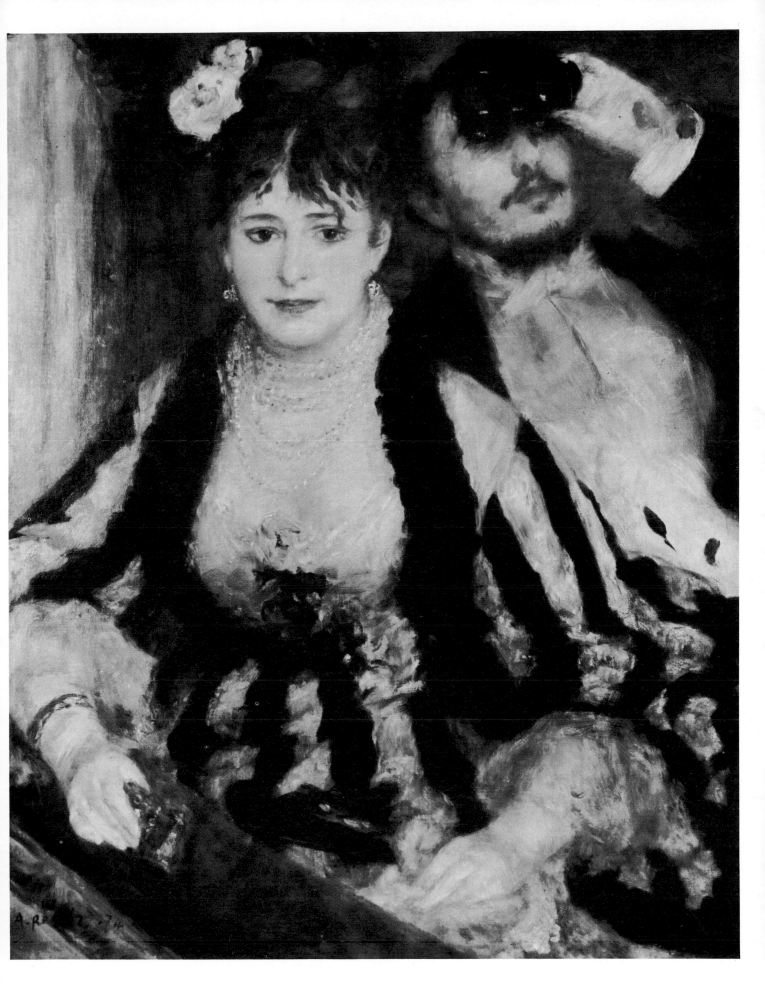

59. The Classic Arch for Harmony and Strength

The arched-line movement is one that binds the shapes in a composition close together, expressing harmonious strength through its heavily swinging action. Therefore, when you wish to paint a subject suggesting a serious and introspective mood, use shapes that form an arched design. This is clearly demonstrated in the painting shown here. The composition is made up of a series of three arches: the first and main one is the alcove, the next is the figure of the Madonna in a curved position, the third is the rounded form of the Child in her lap. The composition is a perfect example of how the classic arch form can be used as the basic structural shape in a composition. There are a great number of possible combinations where you can use the classic arch in a painting. A row of heavy trees forming an arch over a country road, for example.

Any idea that comes to mind will do, just so long as the shapes are in the form of a classic arch.

Materials:
Canvas, 18" x 24"
Full palette of colors
Assorted brushes

Select colors that suggest weight when you plan the color scheme—such as dark versions of the primaries—and have them in sharp contrast to the space outside the arch pattern. Make the arch the substructure rather than just the silhouette of the design. If the forms and colors of your composition are an ensemble of forces perfectly in order, neither too strong nor too weak, with even and constant tonal values, your finished painting will surely express harmony and strength.

Fra Filippo Lippi: Madonna and Child.
Tempera on wood, 31⅜" x 20⅛".
National Gallery of Art, Samuel H. Kress Collection, Washington, D.C.

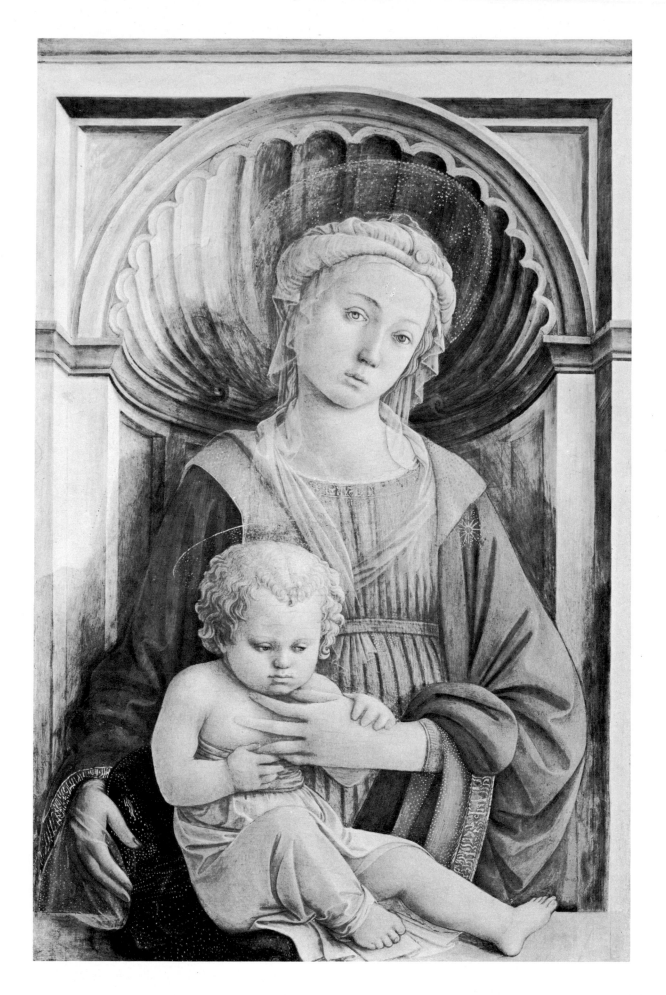

60. Staccato Tempo Expresses Activity

The purpose of this project is to show how when images are repeated rapidly in a staccato arrangement, they make the eye dance in the compositional space. People engaged in a ritual dance would be a good subject for a painting where you intend to use a staccato tempo to express activity.

Notice how in the painting shown here the artist has done this very thing. The spirited interpretation of a traditional dance is rendered with a linear pattern, and the formally attired, angular dancers move to the staccato rhythms of the design of the background area of the composition. Abrupt contrasts of light areas and dark ones dominate the linear pattern of the dancing figures, the prevalence of the dark–light patterning adding to the keen sense of activity in the compositional space.

To get back to your painting: first think of some lively music, then of the ritual dance that corresponds to that music. Think of the American Indian ritual sun-dance, children frolicking around a may-pole, or a group of Hawaiian girls dancing the hula. Any one of these will do.

Materials:

Canvas, 20" x 30"
Full palette of colors
Assorted brushes

First plan a pattern composed of sharp dark and light areas, then superimpose simplified versions of the dancing figures over this ground. Include exciting shadow shapes as part of the picture structure. Keep the action lines sharp and angular and paint with little or no gradations of the colors. Remember, color masses attract or repel, push or pull, and lines become directional, so the accent must be in the way you use the short, angular edges of the shapes in your picture.

The final effect should be a lively, rhythmic interpretation of your subject.

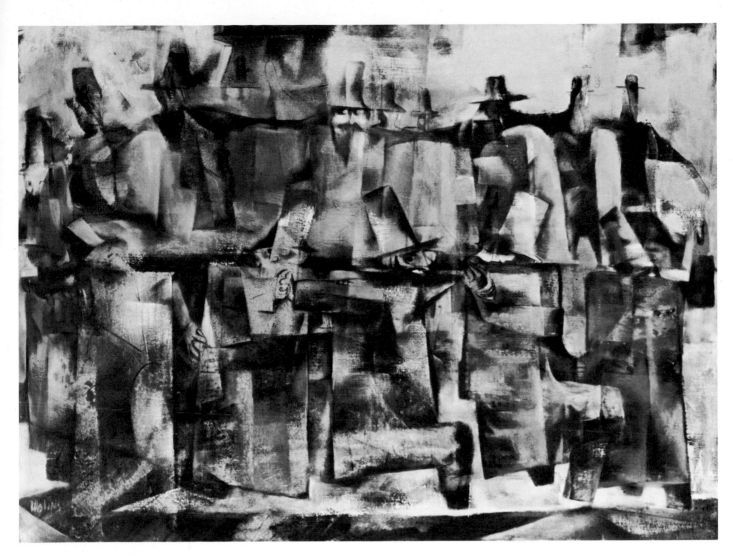

Joseph Wolins: Grand Hora.
Oil on canvas, 36" x 48".
Collection of the Artist

61. Counterpoint Motifs

For this project we'll use counterpoint motifs in a lively, nonobjective composition. In music, where the term originates, counterpoint exists when there are, let us say, two (actually there can be as many as three or four) fully developed melodies being played at the same time. When heard all at once, a third and fuller harmonious *new* melody results. In painting, instead of melodies and chords, you'll be using linear motifs, forms, and colors. When superimposed, these will produce a new image having a unique three-dimensional quality.

In the painting reproduced here, there are two dominant motifs flowing through the compositional space. Each one is a complete motif, independent of the other yet at the same time relating to the other. One motif is dramatic: the forms are boldly defined with angular lines and dark forms. The other motif is poetic: it is defined with lyrical, light-value colors. The combination of the two motifs creates a third image structure that suggests atmosphere, new dimensions, and offers a uniquely effective vehicle for the poetic expression of the artist's ideas.

Materials:

Tracing paper, 18" x 24" (two sheets)
Canvas, 18" x 24"
Full palette of colors
Assorted brushes

For your painting expressing counterpoint, first make several preliminary sketches, each one different from the other. Select the best two and redraw them onto the tracing paper. Make sure the motifs complement one another and do not block each other out. From time to time as your drawing progresses, you'll be able to check on this by placing one sheet over the other. Draw one complete motif on one sheet, the other on a separate sheet. Place one on top of the other and staple them together. Then draw what you're now seeing onto your clean canvas and start to paint.

As you apply the colors, think of each motif as if it were independent of the others, yet at the same time keeping track of what is taking place in the composition. Make sure that the relationships will work together and not against each other. The aim is to achieve a mass of harmony by means of combining separate, independent motifs so that when seen together they convey a totally new expression.

The final step, of course, is to study what you've accomplished so far and eliminate whatever features that seem to be superfluous—so that the control of the spatial break-up is consistent.

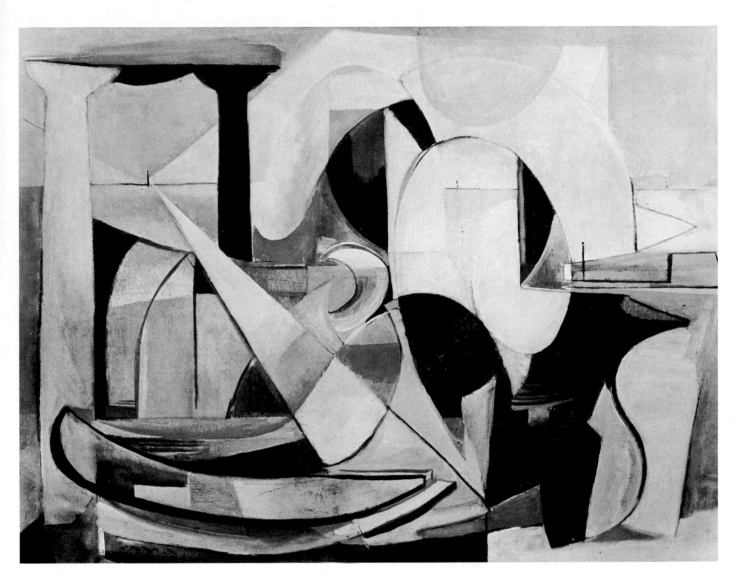

Lucia Salemme: The Echo.
Oil on canvas, 33" x 44".
Collection of the Artist

62. Linear Forms in Movement

In this project we'll suggest movement, using line in an overall pattern-like design of a landscape. When we speak of movement, we not only mean the visual motion that different shapes create, but also the in-and-out movements achieved through visual perspective.

A study of Byzantine and Persian art reveals that instead of showing movement within deep space in a picture, its artists were mainly interested in the flat overall pattern made by the scene. They placed the different picture planes one above the other (instead of one *behind* the other), making no attempt to render spatial depth. It was not until the Renaissance in Italy that visual perspective was explored. In this marvelous painting by Raphael, the best of the two cultures is represented: the flat overall approach of the Byzantines and the knowledge of spatial depth of the Renaissance masters. Note the beauty of composition and the technical mastery in rendering movement by using the exquisite edges of all the forms. St. George looms large in a perfect triangle break-up of the foreground space. Behind him, in a series of receding horizontals, the contours of large rocks, slender trees, a distant city, and the rounded edges of the dragon and St. George on his magnificent white horse. Each form flows gracefully into the next in a continuous linear action, and the whole is painted in the luminous colors that Raphael is noted for.

But now, to work on your painting of a landscape composition, stressing linear forms in motion.

Materials:

Canvas, 24" x 18"
Full palette of colors
Assorted brushes

For your subject think of an idyllic landscape, one that will include hills, trees, a lake, and people basking in the sun—all arranged in a linear pattern on your canvas. You might consider planning an aerial view of the scene as a more effective way of rendering the movement. For example, imagine flying above the scene: you'd get an unbroken view of all the characteristic elements of a country scene. Plan the breakup of the compositional space with shapes that are of different dimensions but that occupy equally key positions in the picture space. The forms should create an interweaving pattern with no abrupt surprises. Stress the linear qualities and use as many graceful, flowing edges as possible. The forms flowing into one another will create the visual movement.

Use smooth brushstrokes in painting the forms, as the rendering of linear movement is best expressed by flowing draftsmanship. Use thick lines for close, distinct areas—thin lines for indistinct, distant areas. The finished canvas will be not too unlike a tapestry.

Raphael Sanzio: St. George and the Dragon.
Tempera and oil on wood, 11⅛" x 8⅜".
National Gallery of Art, Andrew Mellon Collection, Washington, D.C.

PART SEVEN
COLOR AND COMPOSITION

63. Optical Mixing

Optical mixing—the basic principle underlying the pointillist technique—is a substitute for mixing pigments on a palette. The hues produced when you let the eye do the mixing are far more intensely luminous than those same pigments mixed on the palette.

As Seurat was the chief exponent of this technique, let's study one of his paintings. Notice how he's divided the primary colors into their complementary components. For example, instead of painting the wall with a flat violet color, he's used small dabs of blue, red, and white, and painted them very close to one another so that when the canvas is looked at from a distance, the viewer's eye does the mixing: instead of seeing blue and red dots, he sees a violet-colored wall. Similarly, the lovely flesh tones of the seated model are produced with a series of juxtaposed white, yellow, red, and blue dots.

Here are a few hints to help you paint in the proper pointillist technique. For an orange color, use alternate groupings of yellow and red dots. For a green effect, use alternate groupings of small yellow and blue dots. And to get the effect of purple, use a series of red and blue dots. Intersperse your color dots with dots of white to lighten and black to darken.

For your painting, choose a subject that will give you ample opportunity to explore this exciting technique. Remember, you'll be using color in its purest sense, with very little black and white. Sea and landscape subjects lend themselves admirably to this method of painting. So let's do a country scene by the sea.

Materials:
Canvas, 16" x 20"
Full palette of colors
Assorted brushes

First divide the canvas space into three sections, one each for land, sea, and sky. Then plan the basic color for each area. Start painting all the large masses first—sky, hills, water, and large trees—working from the top of your canvas down to avoid smudging any wet areas.

The pointillist technique requires that you use a separate brush for each clean color, so start by applying tiny dots of clear color to each area. Add dots of white or a lighter version of the ground color for the light masses of your forms; for the shadows, add dots that are darker versions of the original color, interspersed with complementary colors and a little black. Next, fill in your smaller areas, such as houses, boats, people, and small trees. Finally, paint in your details, using a small brush to apply the solid patches wherever they're needed.

As you can see, a great deal of patience is required as the progression is slow, but the final result will be well worth the effort.

Georges Seurat: Model in Profile.
Oil on canvas. Jeu de Paume, Paris.
Courtesy of Scala Fine Arts Publishers, Inc., New York

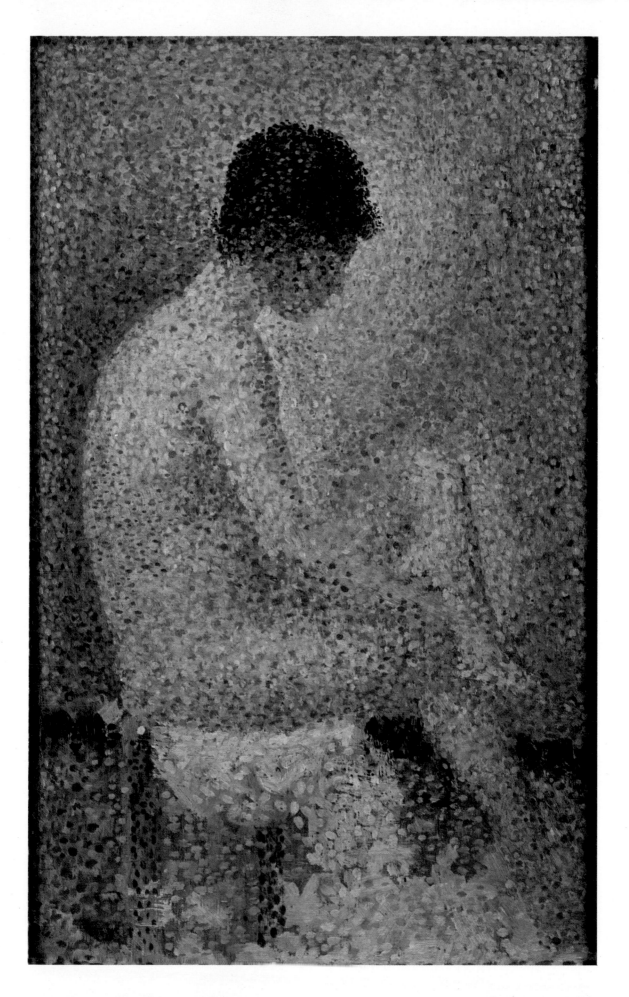

64. Juxtaposed Strokes with the Palette Knife

In this method of painting, color is used in its purest sense. No black or white, just color. Pure colors are juxtaposed, and the illusion of dark and light is created by clear color combinations. The post-impressionists, and later the pointillists, used this method.

Study the painting reproduced here and note how the artist has spread broad dabs of clear color onto the canvas. The colors are distributed in patterns that surround the central theme. The checkerboard windows are all painted in bright colors, with the center window painted a bright yellow, making it the focal point of the composition and accenting all the other color areas.

Try doing a painting of your own using juxtaposed strokes, and just to be different try working with a palette knife instead of with brushes.

For a subject, try using the facade of a city building in a geometric pattern break-up of your pictorial space.

Materials:

Canvas board, 18" x 24"
3" Trowel-shaped palette knife for applying paint
4" Flat-bladed palette knife for mixing
Roll of paper towels

Before we begin, a word about painting with a knife. There are many methods: you can spread, squeeze, or tap broad or tiny dabs of color onto the canvas; you can use the edge of the knife to make lines. Experiment and see which method you prefer. You'll realize that there are as many styles of palette-knife painting as there are styles of penmanship. Also, there are many types of knives sold in art supply stores to suit the tastes of individual artists. Try them out and choose the one you feel most comfortable with. The one that I find takes care of most painting problems and the one I recommend is a knife that has a 3" blade tapering to a fine point at the tip.

The technique of palette-knife painting is sometimes called the *impasto* technique. Its chief characteristic is in the raised paint ridges which create another dimension on the flat surface of the canvas. The thickness of the paint suggests an in-between link between a flat, two-dimensional surface of brush painting and the three dimensions of sculpture. You'll note that the raised ridges of the paint dabs will both catch the light and cast shadows, thus creating the feeling of volume and adding depth to the composition.

Another advantage of this technique is that it's possible to work long hours while the painting is wet. You'll find that you're able to start and finish a picture in one sitting. To maintain a clean, orderly canvas and render a clear, crisp image of your subject, wipe the knife clean after each color used. (You'd be surprised at how quickly things can get out of hand if you don't get into the habit of wiping the knife!)

Now back to your painting. Develop an interesting composition of your city building, then use a neutral color to sketch the subject onto your canvas board. Prepare your palette for painting by mixing all the colors you intend using beforehand. Mix ample amounts of each, as you'll be using much more paint in this method of painting than when using brushes. With your trowel-shaped painting knife, apply paint to your large areas first. Put down a large blob. With the flat part of the blade, extend the strokes in a consistent direction so that you always have visible ridges. Next, juxtapose adjoining colors, playing light against dark, cool against warm, complementaries next to primaries; the result will be a festival of colors.

This is no technique for the timid—so paint brave! If you make a mistake, you can easily scoop it off with your flat knife and then continue the painting. A word of caution about your edges. A hard edge will make your subject look mechanical, so use sharp edges only where attention is wanted without mystery. Of course the reverse is true when you're seeking softer and more poetic effects. The direction of each stroke should follow the shape of the image you're painting.

Make sure you have one area in your composition that is the focal point. Use your brightest color in this spot; it will brighten the whole picture. Your finished painting should be a fine example of color used in its purest sense.

Lucia Salemme: City Windows. *Oil on canvas, 41" x 30". Collection of the Artist*

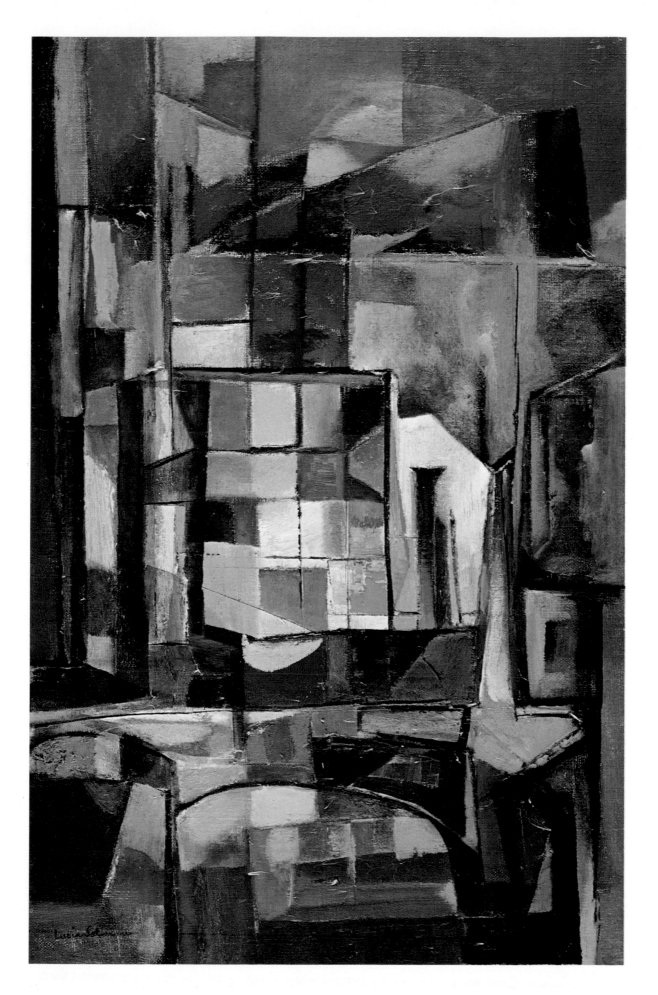

65. Pictorial Depth and the Normal Vanishing Point

In this project we'll be concerned with showing pictorial depth, using the three main rules of perspective—a horizon line and a vanishing point, diminishing proportions, and using color to show depth—all together in one picture. The first step in transferring a three-dimensional world onto the flat, two-dimensional surface of the canvas is to establish your vanishing point. A good place to begin is to place it right in the center of your horizon line. This is known as a "normal" vanishing point.

Look at the reproduction here to see how a master handles the problem of showing pictorial depth. Raphael has brilliantly made use of the three rules of perspective: first, with an exquisite rendering of linear perspective; second, with the diminished size of the figures as they recede into the background; finally, in his use of subtle atmospheric color to show deep space. These factors have been combined to create a glorious example of pictorial depth. Muted color glows over the entire canvas, and the solemn ceremony being enacted by the figures standing upon the path leads the viewer's eye directly toward the chapel majestically placed against a luminous sky.

For a subject for your painting, you might use a street scene showing several figures standing in the foreground engaged in a modern-day activity or sport.

Materials:
Canvas board, 30" x 24"

Full palette of colors
Assorted brushes

Start by making several preliminary sketches on paper. Place your horizon line one-third from the top edge of your paper and put the vanishing point in the direct center of the horizon line. Then sketch guide lines leading up to the vanishing point. You could include an avenue with buildings on either side of it, and figures in the foreground. The figures should be larger than the other elements in the composition. Make several sketches and select the best. In planning your layout, leave no room for accidental effects. Work everything out, then select the version of your idea that you like best. Redraw it onto your clean canvas board.

Now that you're ready to start painting, color is the next consideration. It should be used to emphasize your statement, so select a color scheme that will best express the mood—and more important still, the time of day or night—you have in mind. Also decide on the season of the year so you'll be able to render the proper light and dark tonal effects. Use strong, dramatic colors for foreground shapes, subduing them for receding background areas.

As a final step, study what you've accomplished so far, eliminating whatever features that seem superfluous to the idea of showing pictorial depth with a normal vanishing point.

Raphael Sanzio: The Marriage of the Virgin.
Oil on canvas. Galleria Brera, Milan.
Courtesy of Scala Fine Arts Publishers, Inc., New York

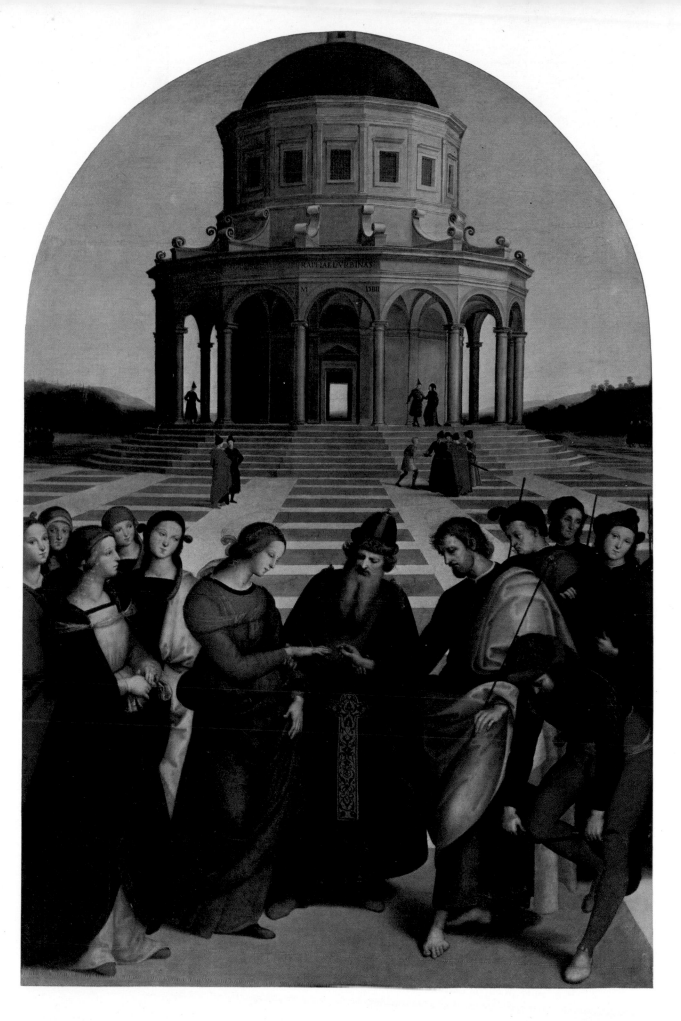

66. Suggesting Three Dimensions with Thick and Thin Paint

The purpose of this exercise is to show how you can produce the illusion of three dimensions on a flat, two-dimensional surface by varying the thickness of the paint you apply. For instance, when you want a shape to come forward, use very thick paint; for a shape or space in the middle distance, use a thinner but still slightly visible brushstroke; on the areas that you wish to recede, use very soft, flat brushstrokes, especially on the edges. Put this to the test and do a three-dimensional landscape, containing mountains, houses, and trees, as in the impressionist landscape shown here.

Let's look at how Renoir has created a striking "back-and-forth" action that suggests three dimensions on the flat surface of the canvas. The figures in the foreground are painted with very thick layers of paint applied in distinctly visible brushstrokes; the middle distance, composed mostly of small boats and water, is painted with applications of medium-thick paint; the far distance is painted with soft, flat brushwork. This controlled handling of thick and thin applications of paint creates a lovely three-dimensional illusion of figures in a landscape. Using Renoir as a guide, let's see how you too can create a landscape of your own using thick and thin paint.

Materials:
Canvas, 20" x 24"
Full palette of colors
Palette knife
Flat bristle brushes, Numbers 2, 4, 6, 8, 10
 (one each)

First plan a composition with forms that go back and come forward. Imagine a series of elements that would be characteristic of a country landscape, such as trees, lakes, houses, or rolling hills, and think of them in terms of planes and masses. Separate the trees, the farmhouse, and the hills, and consider each as an individual mass form. Arrange these mass forms on your canvas so that you're aware of which forms go back and which come forward. And just to complicate things a little, try to superimpose one or two of the objects in your landscape. Also, you know these objects have volume; suggest this in your painting. You can render volumes in space by varying the thickness of the paint on each shape and even on the different parts of the landscape.

To sum up. For the areas that you want to recede, paint the area, especially the outside edges, with soft, flat brushstrokes. For the advancing areas, use very thick layers of paint. You can use your palette knife for this. And last, for areas in the middle distance, use a medium-thick, visible brushstroke.

Your control over the application of paint will determine how much you've succeeded in creating a three-dimensional illusion. When you view your painting from a distance, you should see an astonishing array of forms in space on the flat surface of the canvas.

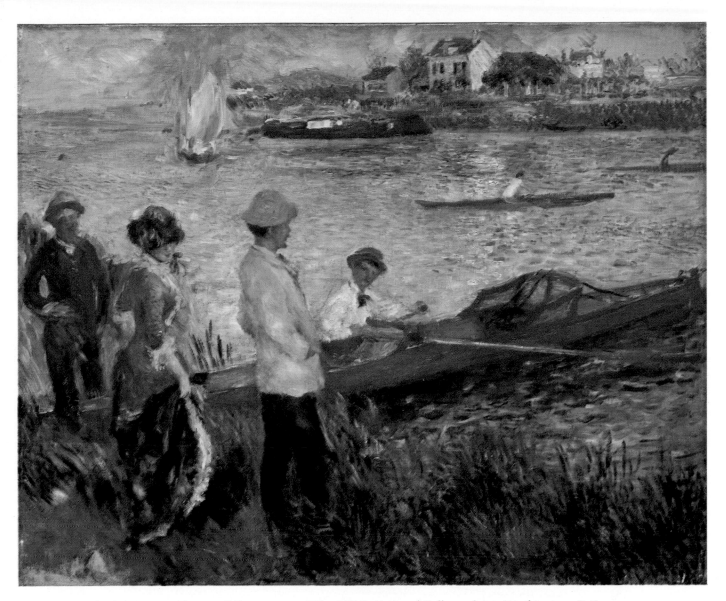

Auguste Renoir: Oarsmen at Chatou. *Oil on canvas, 32" x 39½". National Gallery of Art, Washington, D.C.*

67. Abstracting a Still Life with Primary Color

The best way to abstract an object is to first reduce it to its basic geometric shape, eliminating whatever you consider to be nonessential to its identity and using color to express whatever mood the subject suggests. Let's look at the master of abstraction, Pablo Picasso, and see how he's done just this in the lusty abstraction shown here.

The first thing you'll notice is that he's made no attempt to render logical perspective—selecting angular lines and edges would identify the floor, walls, window, and door of the room interior. The mandolin is an oval form, its neck is a rectangle, with the frets, keys, and strings shown as design elements that identify it as a musical instrument. The guitar is treated similarly, as are the other still life objects on the abstracted cloth and table top. Notice how the balcony motif is repeated on the floor between the table legs, creating a wonderful feeling of open space in the otherwise flat composition.

For your painting, select still life objects with forms that appeal to you. Set them up in a pleasing arrangement, then proceed to study the group, making many sketches before starting to paint the arrangement you like best.

Materials:

Canvas, 24" x 30"
Full palette of colors
Assorted brushes

In abstracting your objects, be guided by their natural contours. Single out fragments of some of the forms, selecting a view that you like best. Enlarge your fragment so it fills an entire page. It might help if you first make a fairly realistic rendering of your set-up and then abstract your rendering; you may find it easier to distort a rendering rather than each object individually. Plan your composition so that the objects are the main theme. Place them in a key spot on the canvas, and have all the other elements, such as the table top, surround your center of interest. Next plan the shadow areas, abstracting these also, and use them as design forms to accent your subject. Finally, select a color scheme, relying mainly on the primaries. Apply the paint with flat, modified brushstrokes to complement the excitement of your composition.

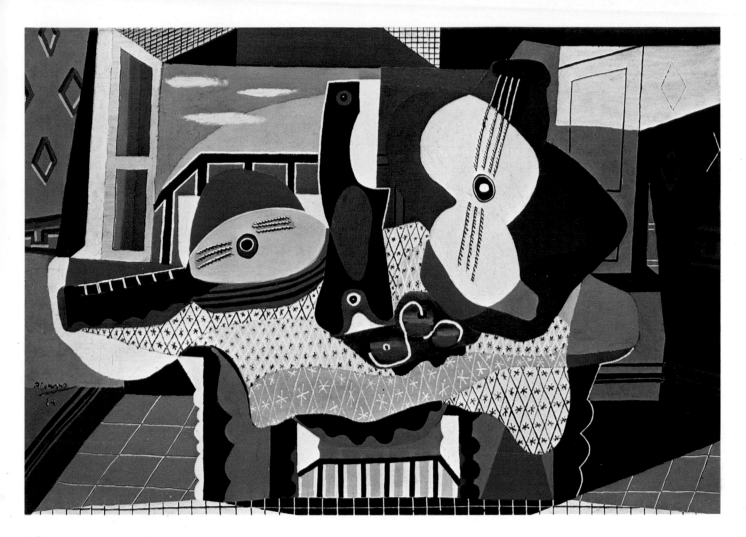

Pablo Picasso: Mandolin and Guitar, *1924.*
Oil with sand on canvas, 56⅛" x 79¾".
The Solomon R. Guggenheim Museum, New York

68. Chiaroscuro

Chiaroscuro is an Italian term that literally means light-dark. This project will show you how you can create the powerful, dramatic effect achieved when dark (almost black)-value colors and light (almost white)-value colors appear with very few middle values in the same composition. Climactic areas in a composition are much heightened when surrounded by extreme darks and lights, which direct the viewer's attention directly to the focal point of the composition. When you add other colors to this dark-light substructure, they in turn create the transitional *middle tones* that hold a composition together.

This painting clearly illustrates the use of chiaroscuro. First, there is a definite climactic area: the placing of the altar of Juno in the very center of the composition makes it the pivot around which the four priestesses revolve. This climactic area is in stark whites so that it becomes the chief source of light; it casts sharp reflections on the faces of the five figures, and the dramatic chiaroscuro effect is created. The viewer's eye is further directed toward this climactic spot by the graceful interweaving gestures of the figures as they move within the confines of the oval composition. An additional spatial dimension in the composition is achieved with the shadows of the figures juxtaposed against the sharp light areas.

The faces of the priestesses are painted in colors that radiate a celestial glow. The subtle, light-value colors of the top center figure behind the silhouette of the dark foreground figure create a continuing pattern, directing the viewer's eye toward the statue of Juno and the tray of jewels offered by the graceful figure of the woman in the center.

In doing your own chiaroscuro painting, plan a composition using a group of five figures seated around a campfire at night. This subject will provide ample opportunity to include wild, black forms. You may, of course, wish to use another subject, but it should fit in with the idea of chiaroscuro.

Materials:
Sketch pad and charcoal
Canvas, 24" x 30" or larger
Full palette of colors
Assorted brushes

The first step is to draw several preliminary sketches on paper, dramatically distributing all your dark areas and dark forms. I must stress the importance of having a definite underlying plan to express exactly the mood you wish to convey in your painting. Don't be satisfied with the first sketch; do several, then select the best. Decide where your climactic area is to be and use it as the core, or center, around which the other forms revolve.

Arrange the placement of each figure so that each form picks up where the other leaves off, creating a continuous motion that leads to the climactic point—the campfire. Now to select your favorite sketch, redraw it on your clean canvas, and start to paint.

The fire and the lighted areas immediately surrounding it will be the brightest areas of the canvas and should be painted accordingly. Use attention-getting light colors like yellows, whites, and oranges for the figures closest to the fire. Paint the distant figures in darker colors or blacks. The setting should also include shrubbery or rock forms in the background areas. In other words, paint the fire first, then all the figures, working in sequence out toward the edges of the canvas. As a final step, connect the separate parts of the composition with additional colors. Use them pure from the tube, if you like, as they won't disturb the strong pattern already made by the interplay of the extreme darks and lights.

When finished, the painting should be an effective, highly dramatic rendition of your subject, done in chiaroscuro.

Giovanni Battista Tiepolo:
Offering by Young Vestal Priestesses to Juno Lucina.
Oil on canvas, 46½" x 58½".
Samuel H. Kress Collection,
The High Museum, Atlanta, Georgia

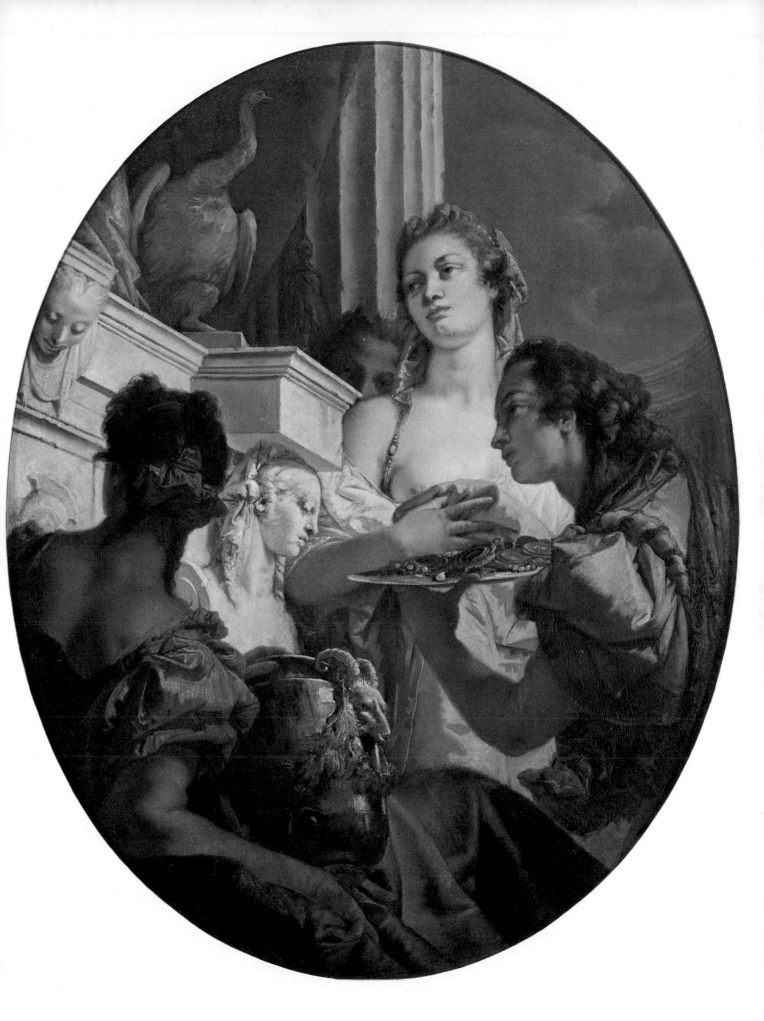

69. Positive and Negative Spaces in a Portrait

Positive space in a painting is likely to be the subject or the area in the composition that makes the statement, such as the face in a portrait or the figure of a model.

What we call negative space would be the areas surrounding the solid forms of the face and figure. It's important to understand that you cannot possibly see positive space unless there's also negative space. You can see this idea in the painting reproduced here. Note that there are positive areas in this portrait other than the model's face—the very solid arms and her blue-clad figure. The key color value is the subject's gown, painted in luminous tonalities of blue. The model's compelling facial expression is intensified by the dark hair which frames the face.

The large subdued area of the background is meant to be the negative space, but to give interest to this large area, and because the subject of the portrait is a singer, barely visible faces and figures from the fantasy world of music have been superimposed. These images are carefully painted so as not to conflict with the main subject, and thus they allow the space to retain its negative character. The ethereal negative space of the background and the solid positive figure in the foreground complement each other, while at the same time emphasizing the specific qualities of each. Put this to the test in a painting of your own, and do a portrait of a friend.

Materials:

Canvas, 24" x 30"
Full palette of colors
Assorted brushes

Start with a strong structural sketch of your subject, carefully planning the different spatial areas of both subject and background. Plan the color scheme so that the key color is on the face. A good basic flesh tone is made by adding Naples yellow and a little alizarin crimson to titanium white. Apply this color to the face, neck, and arms. Now select a color to paint in the background spaces, including the openings between arms and legs, if any, using broad, loose brushstrokes.

While the paint is still wet, and depending on which direction your light is coming from, blend some of the colors that you have on the face into the colors of the background. This is achieved by working the shadow side of the face gently into the background and vice versa. By doing this you'll create an interrelationship between the compositional spaces, placing them all in the same atmosphere.

From this point on, you're ready to concentrate on the most prominent positive area in the composition—the face. Think of the face in terms of its volume at all times, bearing in mind the bone structure and facial planes. The forehead and nose are the two features that project the most. They are in relief outside the hollows of the eyes. Note that the forehead and nose are convex, catching most of the light. The eyes recede, so they are usually in shadow. The line of the jaw shows where the face ends and the neck begins. Paint in all these facial planes with care, establishing the light and the dark areas as you go along.

As a final step, paint in the ears, frame the face with hair, refine your details, and then paint in whatever highlights you think necessary to achieve a likeness of the model. If your portrait is a full figure, the color of the garment plays a major role in the color of the flesh tones as it will be reflected in the color of the face and arms.

When your portrait is finished, the positive spaces in your portrait—the face, the nose, arms and/or hands, and the figure—should retain their dominant role in the composition. without being too obvious.

Lucia Salemme: Portrait of Elizabeth.
Oil on canvas, 50" x 30". Private Collection

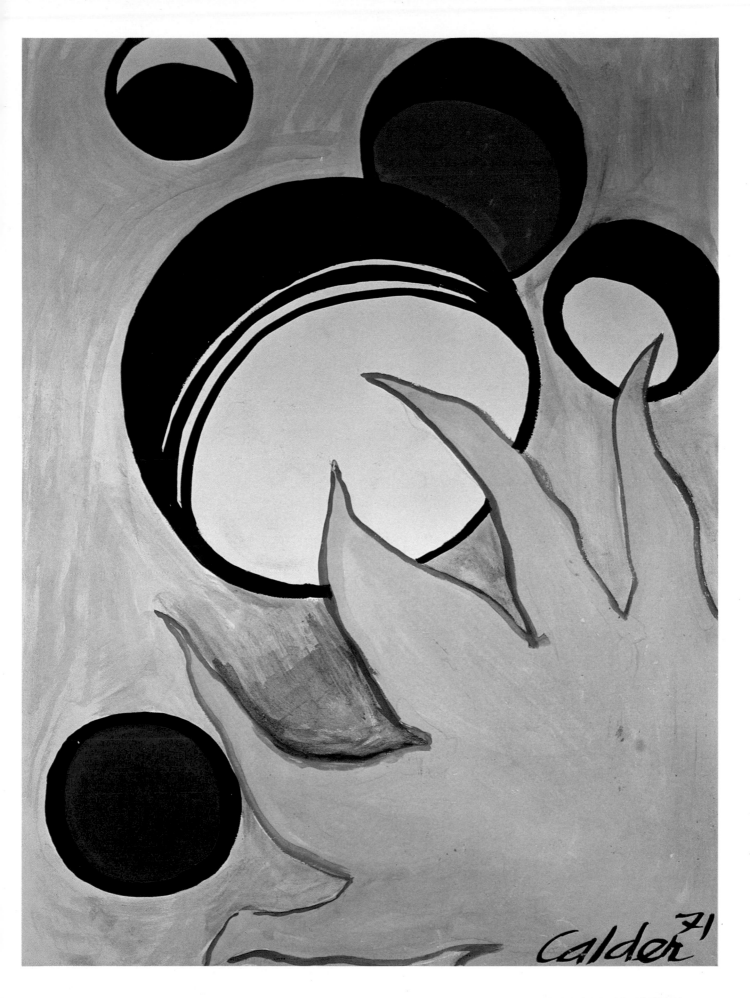

Conclusion

The great masters have taught us that composition does not happen intuitively, that to produce the pictorial illusions found in profound works of art more is required than the intuitive patterning or filling in of spaces with shapes and colors placed next to each other. Those painters who transcend the initial impetus of inspired motivation do so because they know how to utilize the many facets that go into producing structured unity. This unity is what we call *composition*. It reinforces the initial emotional mood of the artist, and it's sometimes the first thing we see in a work of art. We must bear in mind that the painter's emotional state of excitement with his subject is crucial—without it, the structure would be a mere mechanical display of skill. But inspired motivation *combined* with skill is what makes the masterpiece possible.

I've covered many of the facets involved in producing a sound composition in this book, which by no means says that I've covered everything. For instance, I've made little attempt to talk about poetic revelations and styles of composition. These, I feel, are the personal business of the individual artist, to be expressed by him alone. The main concern of this book has been to clarify the major areas involved in composition and to show how all these areas working together can reinforce the painter's poetic mood. The exercises demonstrate how these skills can be put to use, showing how different painters give full impact to the emotional and poetic contents of their statements.

As far as subject matter is concerned, it's important to mention that the artist doesn't rely on some automatic process to select what he paints, and that while poetry may be a part of the artist's subconscious mind, a very definite knowledge of composition is always necessary to enable him to translate these ideas onto the two-dimensional, flat surface of the canvas. In short, the emotional impetus comes first, but the only way it can be expressed is through a sound knowledge of structure and technique.

The subject matter in the paintings reproduced in this book cover a wide range of pictorial ideas. And because the artists chosen are serious artists, masters old and new, I hope a high standard of taste has been presented, stressed, and encouraged. Each painting represents inspired motivation as well as disciplined compositional structure. My selection includes paintings that are narrative in approach (Fra Angelico); single-subject paintings, as in a portrait (Leonardo); paintings that express heroic personality (El Greco); and paintings with subjects taken from life (Renoir), from nature (Rousseau), and from memory (de Chirico). Some of the paintings suggest psychic tensions (Attilio Salemme), and some render the way objects feel rather than the way they look (Picasso). Some are completely nonfigurative, dealing with nonobjective ideas (Kandinsky), while others, on the other extreme, have the romantic realism of the old masters (Rembrandt). But despite their different approaches and subjects, all speak to us with the same voice.

Pictorial art is a universal language. Anyone, no matter what his background, can comprehend it. As the composer must learn his chords and arpeggios to work out the laws of counterpoint, so the painter must master the different aspects of drawing and painting. He must know how to begin, how to develop his theme, how to isolate, how to combine, how to blend, and how to end. He must also know how to understate and how to expand, and whether he should paint a single canvas or a series in order to carry out his ideas. All this is necessary so that when the artist is settled in a studio and working on his own he will have the knowledge and experience that will allow him to fully give expression to his work.

Biographical Notes

New York born painter Lucia Autorino Salemme is a veteran of nine one-woman exhibitions, has been included in the Whitney Museum's "Painting Annuals" twelve times, and is represented in many of the United States' finest public and private collections, among them the Whitney Museum of American Art, New York; the National Gallery of Art, Washington, D.C.; and the New York Public Library Print Collection. She has appeared in group shows throughout the country and at the Chicago Art Institute; the Library of Congress, Washington, D.C.; the Carnegie Institute Museum of Art, Pittsburgh; the Baltimore Museum of Art; the Denver Museum; the Aronson Gallery, Atlanta, Georgia; the Pyramid Gallery, Washington, D.C.; the Whitney Museum of American Art, New York; The Brooklyn Museum of Art, and others. Her one-woman exhibitions have included the Duveen-Graham Gallery, the Dorsky Gallery, Grand Central Moderns, the William Zierler Gallery, all in New York, as well as a retrospective at New York University's Loeb Student Center. Since 1950 her commissions have included an illustrated portrait map of Italy for the Cultural Division of the Italian Embassy in New York, a mosaic mural for the architects Mayer and Whittlesey of New York, and numerous portaits.

Mrs. Salemme studied at the Art Students League, New York, the National Academy of Design, and on a scholarship from the Solomon R. Guggenheim Foundation. She is listed in *Who's Who in American Art*, *1970* and *1973*, and *Who's Who in the East*, *1972–1973*. Mrs. Salemme is also a restorer of note. Her knowledge of painting techniques and materials has won her commissions to restore paintings in the collections of private art dealers as well as institutions.

In addition to her career as a painter, Mrs. Salemme is a teacher and author. She was Instructor for seven years at the Museum of Modern Art, Associate Professor of Art for twelve years at New York University, and currently teaches at the Art Students League in New York, where she encourages the student through skillful motivation to experiment rather than follow stereotyped idioms. She accepts the fact that students come to class with varying abilities, training, and experiences, and that this necessitates an individual approach. She teaches the importance of an alive, emotional interpretation of subject material, encouraging her students to learn to think with excitement —to refer to personal experiences and project these feelings into their work. Her strong background in art instruction coupled with her experience as a creative painter provides a firm base for her career as an author, as is well evidenced by her highly successful first book, *Color Exercises for the Painter*, now in its second printing.

Lucia Salemme is the widow of the noted American painter Attilio Salemme (1911–1955) and is the mother of their two sons, Vincent and Lawrence. She lives and works in New York City.

Index

Page numbers that appear in italic refer to illustrations.

Edited by Margit Malmstrom
Designed by James Craig and Robert Fillie
Set in 9 point Optima by Atlantic Linotype Co., Inc.
Printed and bound in Hong Kong by Toppan Printing Company (H.K.) Ltd.